The New
Drawing
on the Right Side
of the Brain
Workbook

The New
Drawing
on the Right Side
of the Brain
Workbook

JEREMY P. TARCHER/PUTNAM
a member of
Penguin Putnam Inc.
New York

Betty Edwards

Most Tarcher/Putnam books are available at special quantity discounts for bulk purchase for sales promotions, premiums, fund-raising, and educational needs. Special books or book excerpts also can be created to fit specific needs. For details, write Putnam Special Markets, 375 Hudson Street, New York, NY 10014.

JEREMY P. TARCHER/PUTNAM
a member of
Penguin Putnam Inc.
375 Hudson Street
New York, NY 10014
www.penguinputnam.com

Library of Congress Cataloging-in-Publication Data

Edwards, Betty.
 The new drawing on the right side of the brain workbook: guided
practice in the five basic skills of drawing / Betty Edwards.
 p. cm.
ISBN 1-58542-195-2
 1. Drawing—Technique. I. Edwards, Betty. Drawing on the right side of
the brain. II. Title.
NC730.E34 2002
741.2—dc21 2002028769

Cover drawing and instructional drawings by Brian Bomeisler

Book design by Joe Molloy

Typeset in Monotype Janson and Gill Sans by Mondo Typo, Inc.

Printed in Canada

16 15 14 13 12

This book is printed on acid-free paper.

Contents

Foreword

This workbook is designed as a supplement to my book *The New Drawing on the Right Side of the Brain*. Its purpose is to provide convenient, effective guided practice for the five basic skills of drawing. The exercises in this workbook include some familiar kinds of drawings (upside-down drawing, for example) and many new subjects for practicing each skill. For your convenience, the workbook contains an essential drawing tool, a plastic Picture Plane/Viewfinder, which will help you to make drawings that give the illusion of being three-dimensional images and scenes. The workbook is portable so that you can use it in those odd moments of useful time, such as while waiting in the dentist's office or at the airport. As you complete the exercises in these pages, you will be creating a permanent, bound record of your progress in drawing.

Learning to draw is very much like learning a sport or learning how to play a musical instrument. Once you have learned the fundamentals, any advance in skills is based on practice, practice, practice. In this workbook, I will invite you to venture into working with new subject matter and drawing mediums beyond those covered in *The New Drawing on the Right Side of the Brain*.

The exercises in this workbook are based on the five perceptual skills of drawing that I have fully described in *The New Drawing on the Right Side of the Brain*. Drawing is always the same task, always requiring the same five skills that, with practice, become integrated into the whole skill—called the "global" skill—of drawing. It is the subjects and the mediums that change. Because this is true, it really does not matter what you draw—any subject will do, and any medium will do. This is not surprising: all global skills are composed of basic component skills that are always activated when the global skill is being used—think of driving an automobile or playing tennis.

I have found, however, that many of my students who have learned the basic skills find it difficult to choose subjects for drawing. Often, feeling the urge to draw something that catches their eye, they hesitate for fear that the subject may be too hard to draw or that they will not have time to finish. This workbook is designed to solve such problems by providing suitable subjects for practicing each skill, brief instructions, an estimate of the time required (though this will vary somewhat according to your natural pace in drawing), and suitable drawing paper, with ready-

drawn formats and guiding crosshairs in correct proportions for each drawing. For most of the exercises, I have added post-exercise remarks that provide additional information, suggestions, or helpful pointers.

I would guess that the biggest difficulty you will experience in working through these pages is finding the time to draw. Telling yourself that you will draw for an hour each day, or even an hour each week, rarely works. The commitment of even that much time will probably seem too great. You must remember that your brain's language mode—the left-hemisphere, verbal-analytic brain mode—does not want you to draw at all, because it becomes "set aside" while you are drawing. The language mode is very good at presenting reasons why you should not draw: you need to pay your bills, you need to call your mother, you need to balance your checkbook, or you need to tend to business.

Once you actually get into drawing, however, time passes seamlessly and productively. Therefore, I will recommend what has worked for me: a version of the so-called "two-minute miracle," a technique physical therapists use to enable people to exercise even when they do not want to. They are taught to say to themselves, "I don't have time to take a walk right now, but I *will* walk for just two minutes." Once they are actually walking, of course, they forget their objections and continue walking.

Here is my version of the two-minute miracle. Keep this drawing workbook in a convenient place, along with your pencils and eraser. Sit down for a moment and take the workbook in hand, saying to yourself, "I'm not really going to draw now, but I'll just turn to the page of the next exercise." Then, take the next step: "I'm not really going to draw, but I'll just pick up the pencil and make a few marks to start this drawing." Then, "I'm not really going to draw, but I'll just sketch in some of the main edges in this drawing . . ." and so on. You will soon find yourself with a completed drawing—*and unaware that time has passed.*

I realize that this may sound, well, stupid, but it does work. I have completed entire projects using this technique—a technique of (let's face it) tricking the language mode of the brain into letting one do creative work. You may find this hard to believe, but the single most difficult problem for art students and even for working artists is getting the work done. One is always fighting the delaying tactics of the verbal system, whose mantra is "Not now." At its most extreme, the result is writer's block or artist's block; a milder version is called procrastination.

These drawing exercises are designed for success at every step. I know you will enjoy the process.

Note to the reader:

You will find more information on the relationship of drawing to the brain and creativity in my book *The New Drawing on the Right Side of the Brain,* which is widely available in bookstores and libraries. For a two-hour instructional video on the five basic skills of drawing covered in this workbook, see the video-ordering instructions in the back pages of the workbook.

Supplies

The art materials needed for the exercises in this workbook are available in any art supply store. They can also be purchased by mail or through the Internet, by doing a search for "art materials" or "art supplies."

Pencils	#2 yellow writing pencil with an eraser top
	#4B drawing pencil, Turquoise, Faber Castell, or a similar brand
Eraser	A white plastic eraser (Staedtler) or a Pink Pearl eraser
Pencil sharpener	
Graphite stick	#4B
Charcoal	6 sticks of natural charcoal
	2 sticks of synthetic charcoal (CharKole or a similar brand)
	#4B charcoal pencil
Conte crayons	1 black
	1 sanguine (reddish brown)
Chalk	1 pale gray, or 1 pastel crayon
Erasable felt-tip marker	1 black (Crayola, Sharpie, or a similar brand)
Ink	1 small bottle of black India ink
	1 small bottle of brown writing ink
Brush	#7 or #8 watercolor brush
Alarm clock or kitchen timer	
Paper towels or tissues	
White typing paper	About 6 sheets
Lightweight cardboard	1 piece, 8" x 10", to make a frame for the Picture Plane/Viewfinder.

Glossary of Terms

Right brain hemisphere. Left brain hemisphere.

Abstract drawing. A translation into drawing of a real-life object or experience. Usually implies the isolation, emphasis, or exaggeration of some aspect of the real world.

Awareness. Consciousness; the act of "taking account" of an object, person, or surroundings. Possible synonyms are "seeing" or "cognition."

Basic Unit. A "starting shape" or "starting unit" chosen from within a composition for the purpose of maintaining correct size relationships in a drawing. The Basic Unit is always termed "one" and becomes part of a ratio, as in "1:2."

Brain mode. A mental state, implying emphasis on particular capabilities of the human brain, such as language processing or visual spatial processing.

Cognitive shift. A transference of the predominance of one mental state to another, e.g., from verbal, analytic mode to visual, spatial mode, or vice versa.

Composition. An ordered relationship among the parts or elements of an artwork. In drawing, the arrangement of forms and spaces within the format.

Contour. In drawing, a line that represents the shared edges of shapes, or shapes and spaces.

Crosshatching. A series of intersecting sets of parallel lines used to indicate shading or volume in a drawing. Also called "hatching."

Edge. In drawing, a place where two things meet (for example, where the sky meets the ground); the line of separation (called a contour) between two shapes or a space and a shape.

Eye level. In portrait drawing, the horizontal proportional line that divides the head approximately in half; the eye-level line is located at this halfway mark on the head.

Foreshortening. A means of creating the illusion of projecting or receding forms on a flat surface.

Format. The particular shape of a drawing surface (rectangular, square, triangular, etc); the proportional relationship of the length to the width of a rectangular surface.

Image. *Verb:* To call up in the mind a mental copy of something not present to the senses; to see in the mind's eye. *Noun:* A retinal image; an optical image received by the visual system and interpreted or reinterpreted by the brain.

Imagination. A recombination of mental images from past experiences into new patterns.

Intuition. Direct and apparently unmediated knowledge; a judgment, meaning, or idea that occurs to a person without any known process of reflective thinking; an idea that seems to "come from nowhere."

Left-handedness. About ten percent of the population prefers using the left hand for motor activities such as writing or drawing. Location of brain functions may vary in both left and right handers.

Left hemisphere. The left half of the cerebrum. For most right-handed individuals, verbal functions are located in the left hemisphere.

Light logic. In art, the effect caused by a light source. Light rays, falling in straight lines, can logically be expected to cause the following: highlights, cast shadows, reflected lights, and crest shadows.

L-mode. A mental state of information processing characterized as linear, verbal, analytic, and logical.

Negative spaces. The areas around positive forms that, in drawing, share edges with the forms. Negative spaces are bounded by the outer edges of the format. "Interior" negative spaces can be parts of positive forms.

Pencil grades. The grade number stamped on drawing pencils indicates the hardness or softness of the graphite. "H" indicates "hard;" "B" (illogically) indicates "black" or "soft." "HB" divides grades between hard and soft by a middle grade, thusly: 8H (the hardest), 6H, 4H, 2H, HB, 2B, 4B, 6B, 8B (the softest). The #2 yellow writing pencil is the equivalent of the HB or, more commonly, the 2B drawing pencil.

Picture plane. An imaginary transparent plane, like a framed window, that always remains parallel to the vertical plane of the artist's face. The artist draws on paper what he or she sees beyond the plane as though the view were flattened on the plane. Inventors of photography used this concept to develop the first cameras.

Realistic drawing. The objective depiction of objects, forms, and figures attentively perceived. Also called "naturalism."

Relationships. In art, how the parts of an artwork are organized and connected. Also commonly known as *perspective and proportion:* the relationship of angles to vertical and horizontal and the relationship of sizes to each other.

Right hemisphere. The right half of the cerebrum. For most right-handed individuals, visual, spatial, relational functions are located in the right hemisphere.

R-mode. A state of information processing characterized as simultaneous, global, spatial, and relational.

Sighting. In drawing, measuring relative sizes by means of a constant measure (the pencil held at arm's length is the most usual measuring device); determining the location of one part relative to another part. Also, determining angles relative to vertical and horizontal.

Symbol system. In drawing, a set of symbols that are consistently used to form an image—for example, a face or figure. The symbols are usually used in sequence, one appearing to call forth another, much in the manner of writing familiar words. Symbol systems in drawn forms are usually set in childhood and often persist throughout adulthood unless modified by learning new ways to draw perceptions.

Value. In art, the darkness or lightness of tones or colors. White is the lightest, or highest, value; black is the darkest, or lowest, value.

Viewfinder. A device used by artists to frame a view and provide bounding edges to a composition; similar to the device on a camera that lets the user see what is being photographed.

The Exercises

EXERCISE I

Pre-Instruction
Self-Portrait

Materials:

Wall mirror

Masking tape

#2 yellow writing pencil

Pencil sharpener

Chair

Time needed:

About 30 minutes, more if needed

Purpose of the exercise:

Pre-instruction drawings provide a valuable record of your skills in drawing at the present moment, a record that will enable you to appreciate your advance in skills at a later date.

Instructions:

1. Look at page 3 of the workbook, "Pre-Instruction Drawing #1, Self-Portrait."

2. Place a chair in front of a mirror on the wall. (If necessary, tape a small—say, 6" x 8"—mirror to the wall.)

3. Sit at arm's length from the mirror, leaning your workbook against the wall and resting the bottom of the workbook on your knees.

4. Draw your self-portrait to the best of your ability.

5. When you have finished, date and sign your drawing.

Post-exercise remarks:

People are often highly critical of their pre-instruction self-portrait, but if you look closely, you will see areas where you were truly drawing your perceptions—perhaps the turn of the eyelid, the shape of an ear, or the line of a collar. The quality of the drawing may surprise you. Or, if you can find no more to say than "Ugh!" about your drawing, be patient. Drawing is a skill that can be taught and can be learned; it is not magic, and it does not depend on genetic good fortune.

EXERCISE 2

Pre-Instruction Drawing of Your Hand

Materials:

#2 yellow writing pencil

Pencil sharpener

Time needed:

About 15 minutes, more if needed

Instructions:

1. Look at page 5 of the workbook, "Pre-Instruction Drawing #2, My Hand."

2. Sit at a table with the workbook arranged at a comfortable angle.

3. Try out various positions of your non-drawing hand (the left if you are right-handed, or the right if you are left-handed), and choose a position in which you will draw it.

4. Hold your posing hand still and make a drawing of your own hand.

5. Sign and date your drawing.

EXERCISE 3

Pre-Instruction Drawing of the Corner of a Room

Materials:

#2 yellow writing pencil

Pencil sharpener

Time needed:

About 20 minutes, more if needed

Instructions:

1. Look at page 7 of the workbook, "Pre-Instruction Drawing #3, A Room Corner."

2. Look around the room in which you are working and choose one corner to draw. It can be a simple, empty corner, a corner with a few items, or a very complicated scene.

3. Sit in a chair with the workbook on your lap.

4. Draw the room corner to the best of your ability.

5. Sign and date your drawing

EXERCISE 3 PRE-INSTRUCTION DRAWING OF THE CORNER OF A ROOM

EXERCISE 4

Warm-up and Free Drawing

Materials:

Felt-tip marker or #4B drawing
pencil

Pencil sharpener

Time needed:

About 10 minutes

Purpose of the exercise:

This exercise is designed to give you a feel for the very personal expressive quality of pencil lines on paper. You will "try out" the line styles of master artists and then experiment with your own marks, both fast and slow. Your personal style will emerge in the course of using this workbook. It comes from your history, your physiology, your personality, your cultural background, and all the factors that make up *you*. You cannot plan your style or foretell it, but you can watch for its emergence. See page 10 for an illustration of style differences.

Instructions:

1. Turn to page 11 of the workbook, "Line Styles."
2. In Format 1, make very fast "Matisse" marks (see Example a).
3. In Format 2, make medium-fast "Delacroix" marks (see Example b).
4. In Format 3, make medium-slow "Van Gogh" marks (see Example c).
5. In Format 4, make very slow "Ben Shahn" marks (see Example d).
6. In Format 5, make your own marks, some fast, some slow.
7. Sign and date your drawings.

Henri Matisse, *Standing Nude,* 1901–03. Brush and ink, 10⅜ x 8 inches. Collection, The Museum of Modern Art, New York. Gift of Edward Steichen.

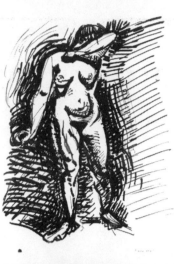

Matisse marks.

Vincent van Gogh, *Grove of Cypresses,* 1899. Drawing—reed pen and ink, 24½ x 18⅛ inches. Gift of Robert Allerton. Courtesy of the Art Institute of Chicago.

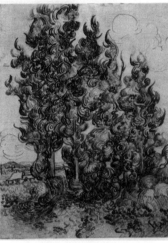

Van Gogh marks.

Eugene Delacroix (1798–1863), *Etudes de Bras et de James,* 1901–03. Pen and sepia ink on buff paper, 217 x 350 mm. Worcester Sketch Fund Income. Courtesy of the Art Institute of Chicago.

Delacroix marks.

Ben Shahn (1898–1969, Russian-American), *Dr. J. Robert Oppenheimer,* 1954, brush and ink, 19½ x 12¼ inches. The Museum of Modern Art, New York.

Ben Shahn marks.

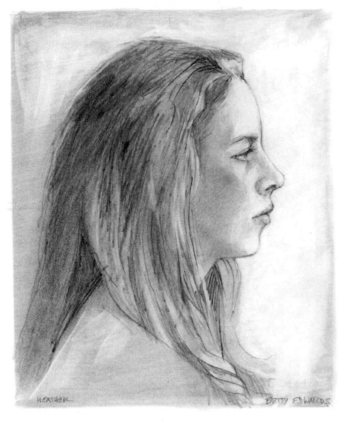

Heather Allen by the author.

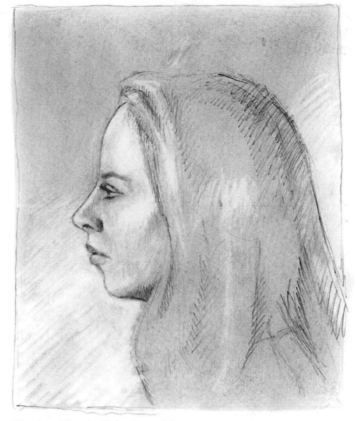

Heather Allen by Brian Bomeisler.

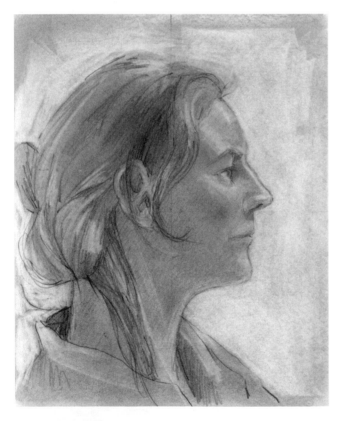

Grace Kennedy by the author.

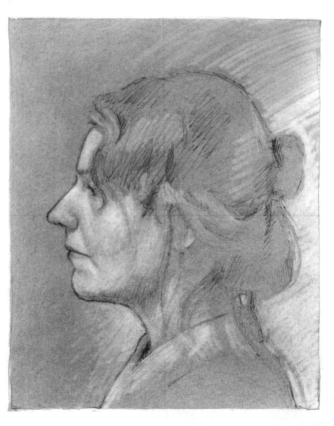

Grace Kennedy by Brian Bomeisler.

These are demonstration drawings by instructor Brian Bomeisler and myself. We sat on either side of the same models, used the same drawing materials, and drew for the same length of time. Yet see how different our styles of drawing are: my style emphasizes line, while Brian's emphasizes form.

EXERCISE 5

The "Vase/Faces" Drawing

Materials:

#2 yellow writing pencil and eraser

Pencil sharpener

Time needed:

About 5 minutes

Purpose of the exercise:

This exercise is designed to demonstrate the possibility of conflict between the brain's language mode, which I have termed "L-mode," and its visual-perceptual mode, or "R-mode."

The "Vase/Faces" drawing is a visual illusion drawing that can be seen either as two facing profiles or as a symmetrical vase in the center. You are given one half of the drawing, and your job will be to draw the second profile—thus inadvertently completing the symmetrical vase in the center.

Instructions:

1. Turn to page 15 in the workbook, "Vase/Faces Drawing for Right-Handers," or, if you are left-handed, to page 14, "Vase/Faces Drawing for Left-Handers."

2. Redraw the profile already printed on the page. With your pencil, go over the lines, naming the parts as you go: "Forehead . . . nose . . . upper lip . . . lower lip . . . chin . . . neck."

3. Next, draw the missing profile that will complete the symmetrical vase.

4. When you come to the point in the exercise shown in the drawings below, you may begin to experience a sense of conflict or confusion. Continue through this moment of conflict, self-observing as you draw to become aware of how you solve the problem..

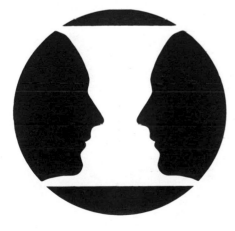

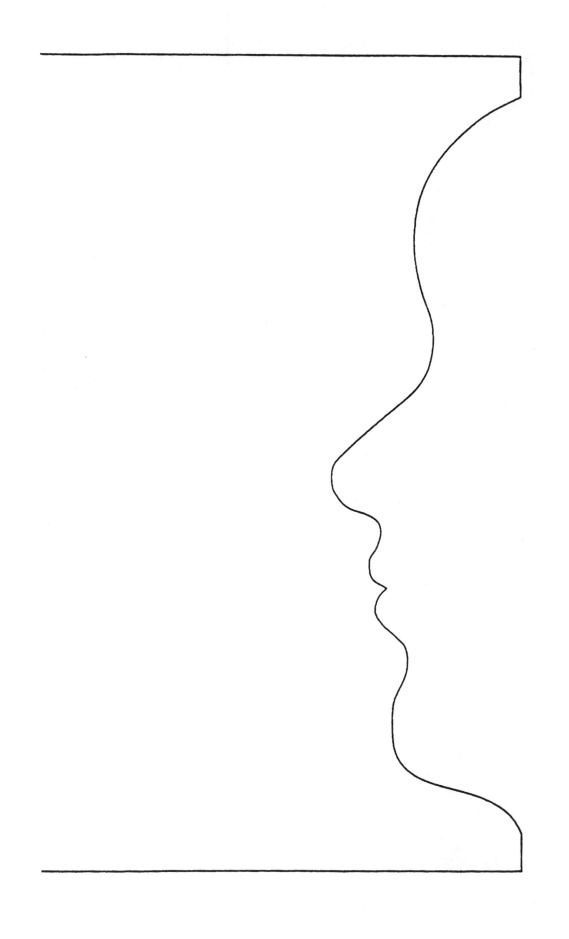

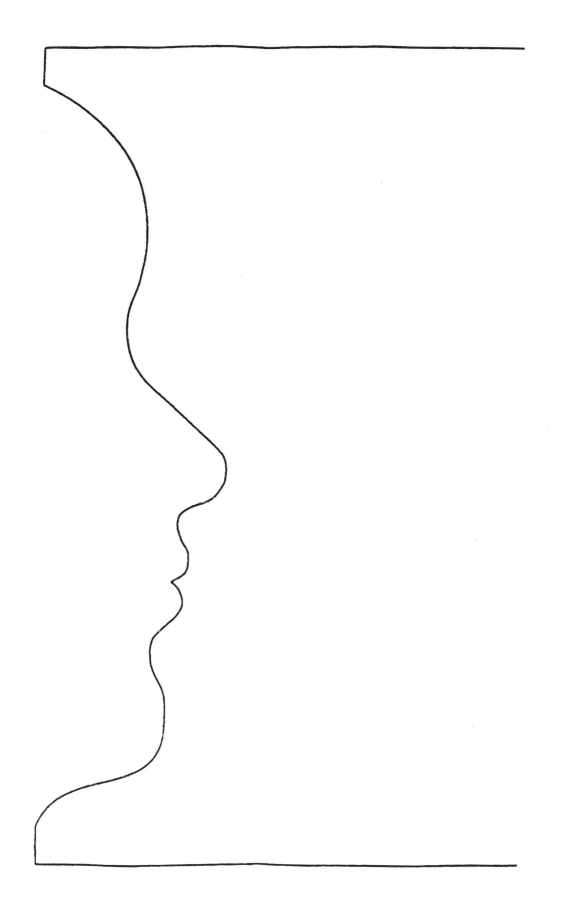

Post-exercise remarks:

You may have stopped at the onset of conflict or confusion and given yourself some instructions to solve the problem, such as, "Don't think of the names of the features. Draw the vase instead." There are many other solutions. Some students start over and work from the bottom up. Some grid the drawing in squares or establish points where the line turns on the outermost and innermost curves.

The reason the exercise causes conflict is that by asking you to name the facial features as you redrew them, I strongly activated your brain's language mode. Then I gave you a task (to draw the missing profile in reverse orientation) that can be achieved only by making a mental shift to the visual, perceptual, relational R-mode. For most people, the struggle to make that shift is marked by a sense of conflict or confusion.

EXERCISE *6*

Upside-Down Drawing

Materials:

Picasso's 1920 drawing of the composer Igor Stravinsky, page 18; or, alternatively:

the drawing of the horse in foreshortened (frontal) view, page 20;

the drawing *Horse and Rider*, by an unknown German artist, page 22;

or the figure drawing by the Austrian artist Egon Schiele, page 24.

#2 yellow writing pencil, sharpener, and eraser

Pencil

Time needed:

30 to 40 minutes

Purpose of the exercise:

This exercise is designed to *reduce* conflict between brain modes by causing your language mode to drop out of the task. Presumably, the language mode, confused and blocked by the unfamiliar upside-down image you will be drawing, becomes unable to name and symbolize as usual. In effect, it seems to say, "I don't do upside down," and allows the visual mode to take over. R-mode is the appropriate mode for this drawing task.

Instructions:

1. The drawing you have chosen (the Picasso *Stravinsky,* the frontal view of the horse, the *Horse and Rider,* or the figure drawing by Egon Schiele) is printed upside down. Your copy will also be done upside down. The accompanying page for your drawing is side-by-side with each upside-down image. Starting anywhere you like—most people start in the upper left-hand corner—begin to copy the drawing you have chosen. Note: I advise against drawing the whole outline. If there is any error in the outline, the parts will not fit together. This is quite frustrating to R-mode, which is specialized for perceiving how parts fit together.

2. Moving from line to adjacent line, space to adjacent space, fit the parts together as you go. Try not to name parts as you are drawing. Draw the lines just as you see them, without trying to figure out what you are drawing. When you come to parts that seem to force their names on you—such as the hands and the face—try to focus on those parts as just unnamed shapes.

3. When you have finished your drawing, turn it right side up. I think you will be surprised and pleased by what you see. Just be sure you don't turn the drawing right side up until you have completely finished it.

4. Sign and date your drawing. Include the notation always used for a copied drawing: "After Picasso," "After Anonymous" (for the German drawing or the frontal view of the horse), or "After Schiele."

5. Time permitting, it is extremely helpful to do a second and even a third upside-down drawing, using the drawings you did not choose the first time.

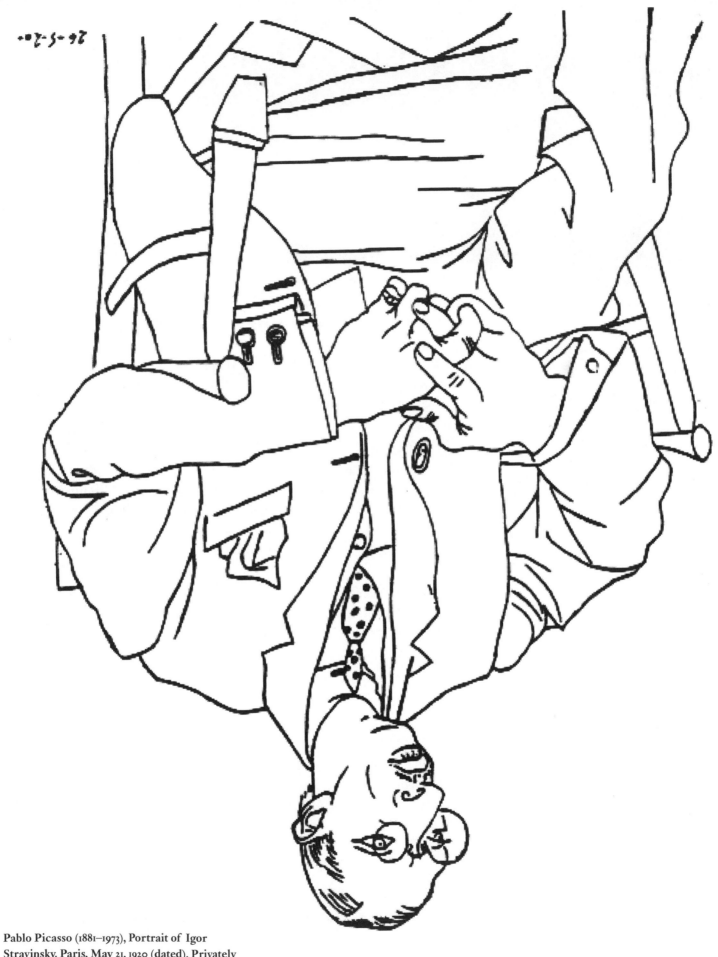

Pablo Picasso (1881–1973), Portrait of Igor
Stravinsky. Paris, May 21, 1920 (dated). Privately
owned. ©2002 Estate of Pablo Picasso/Artist
Rights Society (ARS), New York.

Frontal view of a horse. Artist and provenance unknown.

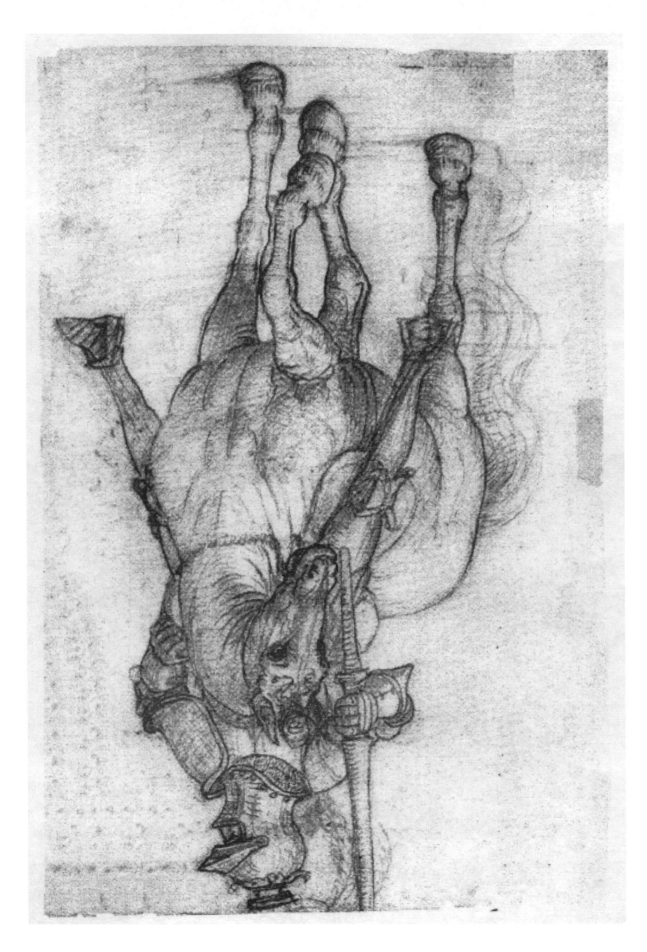

Horse and Rider. German 16th-century drawing.
Artist and provenance unknown.

Egon Schiele (1890–1918),
Seated Woman, 1917. Black chalk.
Private collection, Vienna.

Post-exercise remarks:

It goes against common sense that it is easier to draw something upside down than right side up. When an image is upside down, however, the verbal brain mode is disoriented in its attempt to use visual clues to name and categorize. Therefore, it apparently refuses the task, allowing the visual mode to take over. Since we can't turn the world upside down, our main task in learning to draw is to learn how to gain access to the visual mode even when things are right side up.

EXERCISE 7

Pure Contour Drawing

Materials:

#2 yellow writing pencil, sharpener, and eraser

Masking tape

Alarm clock or kitchen timer

Time needed:

About 15 minutes

Purpose of the exercise:

The aim of this exercise, as with the previous one, is to cause your brain's language mode to drop out as you draw, this time by presenting it with a task that seems boring, repetitive, and unnecessary. A second purpose is to introduce the first basic skill of drawing, the skill of perceiving edges.

Instructions:

1. Turn to page 29 of the workbook.

2. Tape the workbook to a tabletop.

3. Set your kitchen timer for 5 minutes.

4. Sit at the table with your drawing hand holding the point of your pencil in the middle of the workbook page, ready to draw.

5. Now turn around in your seat so that you are facing in the opposite direction. Gaze at a single wrinkle in the palm of your non-drawing hand.

6. Begin to draw that wrinkle, defined in drawing as an "edge." Move from wrinkle to wrinkle (edge to adjacent edge), confining your drawing to what you see in the center of your palm, in an area of about a square inch. Do not attempt to outline your whole hand, and do not turn to look at the drawing you are creating on the page.

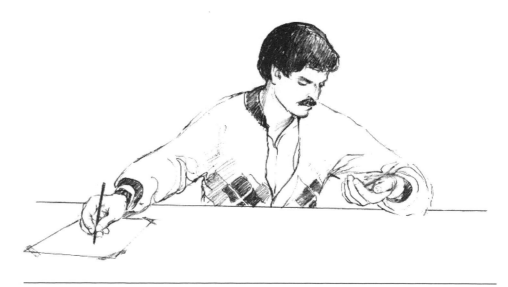

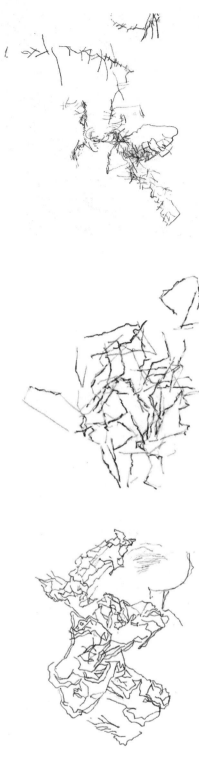

7. As your eyes very slowly track the edge of each tiny wrinkle in your palm, one millimeter at a time, your pencil will record your perceptions simultaneously. Your hand and pencil will function like a seismograph, recording every detail of what you are seeing.

8. Continue to draw until the timer signals you to stop. Then turn and look at your drawing.

9. Sign and date your drawing.

The Five Perceptual Skills of Drawing

The global skill of realistic drawing includes these five perceptual skills:

1. *The perception of edges,* expressed through "line" or "contour" drawing.

2. *The perception of spaces,* in drawing called "negative spaces."

3. *The perception of relationships,* known as perspective and proportion.

4. *The perception of lights and shadows,* often called "shading."

5. *The perception of the gestalt*—that is, the whole, or the "thingness" of the thing.
 With practice, these component skills become integrated into a single, global skill, enabling you to draw whatever you see.

Post-exercise remarks:

Students often laugh when they see their drawings: tangles of indecipherable lines. This exercise, however, is one of the most important in the workbook. Many artists do a bit of Pure Contour drawing (sometimes called "blind" contour drawing) every time they sit down to work.

Pure Contour drawing is the most efficient way I know of preparing the brain for visual tasks. The verbal brain mode, which is seemingly easily bored, finds the task so tedious (and so "useless" in terms of producing a recognizable, nameable image) that it quickly drops out, enabling the visual mode to come forward. R-mode, however, seems to find detailed complexity fascinating and will keep on with the drawing until the timer sounds. If at some point in your Pure Contour drawing you found yourself becoming *interested* in your perception of the tiny area in your palm, that indicates a shift to the visual mode. If not, try another short session.

Examples of students' pure contour drawings.

EXERCISE 8

Drawing Your Hand on the Plastic Picture Plane

Materials:

#2 yellow writing pencil, sharpener, and eraser

Picture Plane/Viewfinder inserted into this workbook. (Remove it as directed. To make the Picture Plane/Viewfinder more rigid, cut a narrow frame—about an inch and a half wide—from cardboard and use tape to attach it to the back of the Picture Plane/Viewfinder.)

Erasable felt-tip marking pen

Slightly dampened tissue or paper towel

Time needed:

About 5 minutes

Purpose of the exercise:

This exercise introduces the concept of the "picture plane," one of the key concepts in learning to draw. The picture plane is an imaginary, transparent plane, like a sheet of imaginary glass that always hangs in front of an artist's face. An artist uses the picture plane to flatten a perceived image (like a photograph) in order to translate the actual three-dimensional scene into a drawing on two-dimensional (that is, flat) paper.

In this exercise, you will use your actual Picture Plane/Viewfinder to draw your hand with the fingers pointing toward your face. This is called a "foreshortened" view, and it is one that most beginning students regard as too difficult to draw. The Picture Plane/Viewfinder will provide an actual surface on which you will draw the flattened image of your three-dimensional hand, and, in addition, a viewfinder to frame the image. Like magic, your flat drawing on the actual plastic plane will appear three-dimensional.

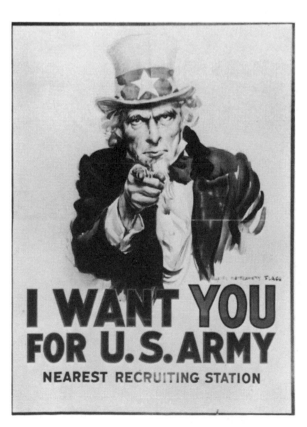

James Montgomery Flag, *I Want You*, 1917.
30 x 40 inches. Poster by Walter Rawls.
Imperial War Museum, London, England.

Note:

To make corrections, set the marker down and use a dampened tissue to erase lines *without moving your posed hand.* Be aware that the felt-tip marker will make a line that is somewhat rough and shaky.

You may want to try this exercise again, with your hand in another position. Simply wipe off the Picture Plane and do another drawing. Try a really "hard" view—the more complicated, the better. Save your last drawing for the next exercise.

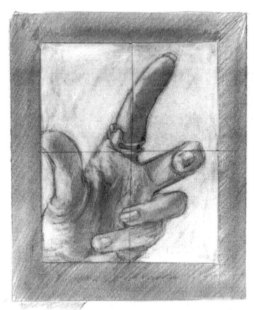

Figure 8-1.

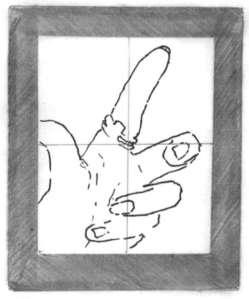

Figure 8-2.

Instructions:

1. Uncap the felt-tip marker and hold it in your drawing hand.

2. Rest your other hand on the edge of a table, with your fingers pointing toward your face in foreshortened view.

3. Balance your plastic Picture Plane/Viewfinder on your "posed" hand. See Figure 8-1.

4. Close one eye so that you are looking at your hand with only one eye. This removes binocular vision—literally, "two-eyed vision"—which produces two slightly different images that are melded together by the brain to provide depth perception. Closing one eye produces a single image, a flat image, of your hand.

5. With the marker, begin to draw the edges of your hand on the plastic Picture Plane/Viewfinder. Draw the edges just as you see them, without trying to figure out why they are the way they are. Be sure not to move either your hand or your head. You must keep a constant, unchanged view. Draw the edges with as much detail as possible (recall the lesson of Pure Contour drawing). Allow the edges of your wrist to touch the edges of the format. See Figure 8-3.

6. When you have finished, place the plastic plane on a piece of white paper so that you can see the drawing on the plastic.

Post-exercise remarks:

With relatively little effort, you have accomplished one of the truly difficult tasks in drawing—drawing the human hand in foreshortened view. How did you accomplish this so easily? You did what a trained artist does: you copied what you saw flattened on the picture plane—in this instance, an actual plastic plane. Understanding how to use the imaginary picture plane is the secret to portraying three-dimensional forms in realistic drawing.

More than any other exercise, this is the one that most frequently causes students to experience the "Aha! So that's how it's done!" of learning to draw. I can now define drawing for you: *Drawing is copying what you see, flattened on the picture plane.*

EXERCISE 8 DRAWING YOUR HAND ON THE PLASTIC PICTURE PLANE

EXERCISE *9*

Setting a Ground

Materials:

#2 yellow pencil or #4B drawing pencil, sharpener, and eraser

#4B graphite stick

Dry paper towel or tissue

Time needed:

5 to 10 minutes

Purpose of the exercise:

"Setting a ground," which means toning the paper you will draw on by rubbing it with graphite or charcoal, provides several advantages. First, the toned ground provides a middle value or shade to which you can add lights and shadows by erasing the lighted areas and darkening the shadowed areas. Second, I find that students seem more comfortable starting a drawing when they have already worked on the paper to tone a ground. For some, a blank white page can seem intimidating. Third, toned paper is very forgiving in terms of correcting errors. It allows you to make corrections invisibly by just erasing a mistake and rubbing to restore the tone.

Instructions:

1. Turn to page 35 of the workbook. You will see a pre-drawn format (a line defining the edge of a drawing) with crosshairs, faint vertical and horizontal lines that divide the format into four equal quadrants.

2. On a sheet of scratch paper, rub down one of the sharp edges of your graphite stick to create a rounded corner.

3. Using the rounded edge of the graphite, lightly shade the area within the format. Use the dry paper towel or tissue to rub the graphite-covered area, pressing very firmly, until you have achieved an even, silvery tone on the paper. See Figures 9-1 and 9-2.

4. If you wish, use an eraser to clean up the edges of the format; or, you may want to leave the soft toned area around the format that is often left from the rubbing process.

5. Practice "making a mistake" and fixing it. Make a pencil mark on the toned area, erase it, and rub the tone again until the eraser mark disappears. You may need to add a bit of graphite from the graphite stick or from your pencil and then rub again.

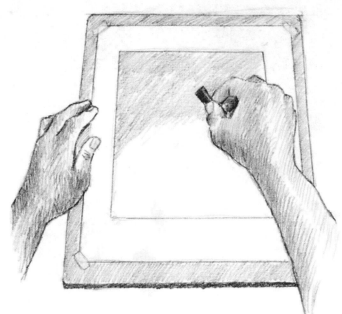

Figure 9-1.

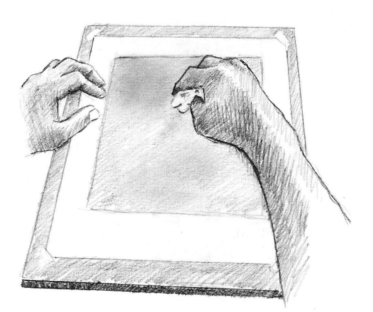

Figure 9-2.

Post-exercise remarks:

Your paper is now ready for the next step—a beautiful drawing of your hand. Learning to set a ground is a useful skill. At times, however, you will want to draw directly on untoned paper. In this workbook, you will use both methods.

EXERCISE 10

Transferring Your Hand Drawing from Picture Plane to Paper

Materials:

Picture Plane/Viewfinder, with the drawing of your hand in foreshortened view from Exercise 8

#2 yellow writing pencil, sharpener, and eraser

Time needed:

30 to 40 minutes

Purpose of the exercise:

In drawing a perceived image, an artist copies onto paper the flattened image "seen" on a real or imaginary picture plane. In Exercise 8, drawing your hand on the plastic, I made the imaginary picture plane into an actual plane on which you drew your hand with your felt-tip marker. You will now copy that drawing from the plastic Picture Plane onto paper. Thus, we have inserted an extra step—drawing on an actual picture plane—to accustom you to the process of drawing, which, by definition, is copying directly onto paper what the artist sees flattened "on the plane."

Instructions: First Part of the Exercise

1. Turn back to page 35 of the workbook, with the printed format, the faint crosshairs, and your toned ground from Exercise 9.

2. Set the plastic Picture Plane with the drawing of your hand on it alongside your toned format. You will see that the formats of the Picture Plane/Viewfinder and your toned ground are the same size, and the crosshairs divide the space in the same way. See Figure 10-1.

3. The first step is to transfer the drawing on plastic to your toned paper by lightly sketching in the main edges and spaces. Note where an edge of your wrist touches the edge of the format. With your pencil, mark that point on the paper. Follow the direction of the line on plastic. Ask yourself: What is its angle? Within the quadrant, where does it change direction? See Figure 10-2.

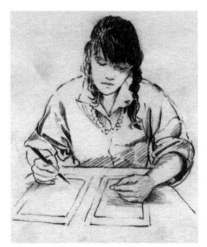

Figure 10-1.

Figure 10-2.

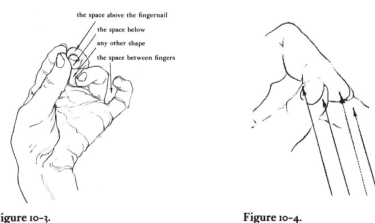

the space above the fingernail
the space below
any other shape
the space between fingers

Figure 10-3.

Figure 10-4.

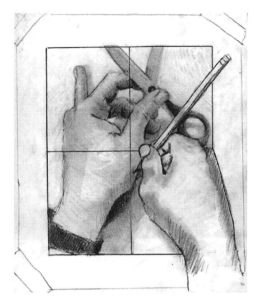
Figure 10-5.

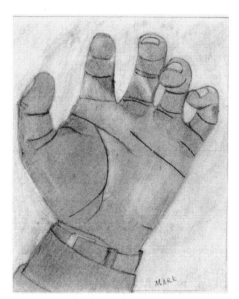
Figure 10-6. Drawing by student Mark Dalgaard.

Figure 10-7. Drawing by instructor Rachael Thiele.

4. Try not to name the parts, such as fingers and fingernails. The edges of the fingernails and the shapes around the fingernails are defined by a shared edge. Shift your focus to the shapes around the fingernails, and draw those shapes. The shapes are easy to see and draw because you have no memorized symbol for them, as you have for fingernails. By this means, you will have inadvertently drawn the fingernails, and you will find that they are correctly drawn. See Figures 10-3 and 10-4.

5. As you transfer the drawing from plastic onto your paper, continue to check all the points where the lines touch the format lines and the crosshairs. Then continue to copy all the angles and curves within each quadrant, noting where each point touches or crosses a crosshair or where a point falls within a quadrant.

Instructions: Second Part of the Exercise

1. When you have finished copying the main edges of your hand drawing from the plastic plane onto paper, you are ready to start turning the sketch into a more detailed drawing, again using your hand as the model. First, set aside the plastic Picture Plane and return your "posing" hand to the position in which you originally drew it on the Picture Plane.

2. Close one eye to flatten the image. Carefully look at each contour edge of your hand. Adjust and refine each edge in your drawing, recalling the lesson of Pure Contour drawing. See Figure 10-5.

3. Half close your eyes to see the large shapes of lights and shadows in your hand.

4. Use your eraser to "draw out" the light shapes and your pencil to darken the shadow shapes. The example drawings, Figures 10-6 and 10-7, will guide you.

5. Sign and date your drawing.

Post-exercise remarks:

This is your first "real" drawing, and I can assume with some confidence that you are pleased with the results. The concept of shared edges—that is, a place where two things come together to form a single, shared edge that, in drawing, is represented by a "contour" line—is an important concept. It helps you to escape the influence of memorized symbols by enabling you to draw easy, unnameable parts while simultaneously and effortlessly portraying the difficult parts. On page 37 is an additional format for practicing this exercise again, drawing your hand in a different position.

Return to the Pre-Instruction Drawing of Your Hand (Exercise 2, p. 5) to appreciate how your skills have advanced. The next three exercises will provide practice based on the above instructions but using different subject matter.

EXERCISE 10 TRANSFERRING YOUR HAND DRAWING FROM PICTURE PLANE TO PAPER

EXERCISE **11**

Drawing Your Hand Holding an Object

Materials:

#2 writing and #4B drawing pencils, sharpener, and eraser

Felt-tip marker

Picture Plane/Viewfinder

#4B graphite stick

Dry paper towel

An object to hold: a pen or pencil, a set of keys, a handkerchief, a small toy, a glove, or anything else that appeals to you

Time needed:

30 to 40 minutes

Purpose of the exercise:

In this exercise, you will again draw your hand. This time, however, your hand will be holding an object, thus adding compositional interest and providing a new challenge while encouraging you to practice the skills you have just learned.

Instructions:

1. Turn to page 42 in the workbook, with the pre-drawn format and faint crosshairs.

2. Use your graphite stick and paper towel to set a ground. You may want to try a slightly lighter or slightly darker ground than the one you used for the last exercise.

3. Uncap your felt-tip marker so that it is ready to use.

4. Hold the object you have chosen in your non-drawing hand and try several poses to find one that you like.

5. Balance the Picture Plane/Viewfinder on your posing hand. Pick up the felt-tip marker, close one eye, and use the marker to draw the edges of your hand and the object on the plastic plane.

6. When you have finished, place the plastic plane on a sheet of white paper so that you can see the marker lines of the drawing. Set your toned format alongside the drawing on plastic.

7. Using your pencil, copy the main edges of the picture-plane drawing onto the toned paper.

8. When you have sketched the whole hand and object onto the paper, set the Picture Plane/Viewfinder aside and return your posing hand, holding the object, to its original position.

9. Again, close one eye to flatten the image and carefully redraw each contour edge, adjusting and refining the drawing as needed.

10. When the edges are drawn, look for the shapes of lighted areas and shadowed areas by squinting your eyes to mask out fine detail. Erase the lighted shapes and use your #4B drawing pencil to darken the shadowed shapes.

11. When the drawing is finished, sign and date it.

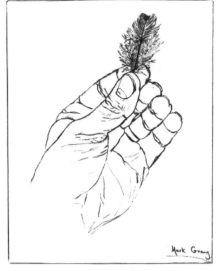

Drawing by student Mark Gray.

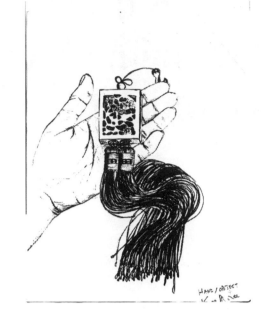

Drawing by student K.M. Lee.

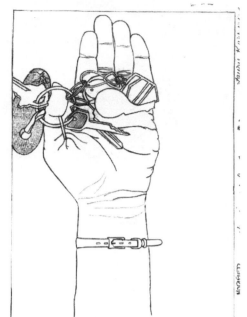

Drawing by student Laurie Kuroyama.

Drawing by student Ethel Branham.

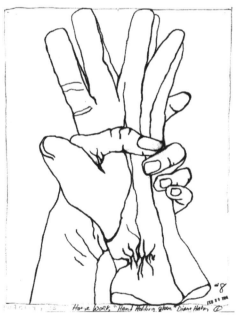

Drawing by student Diane Hahn.

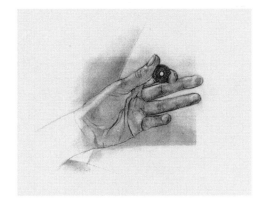

Drawing by Alice Picado.

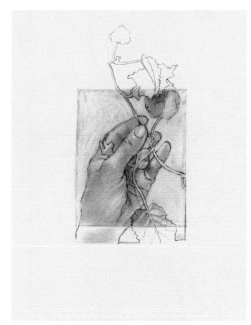

Drawing by the author.

Post-exercise remarks:

This drawing provides opportunities to differentiate textures—here, the difference between the flesh of the hand and the object it is holding. I have found that students are very inventive at using the pencil in a variety of ways to show the differences between, say, a metal object and the hand that holds it. Intuitively, they vary the thickness of lines, the smoothness or roughness of pencil marks, and the lightness or darkness of tone.

This is a challenging drawing, but each time you practice the routine of drawing—that is, choosing a subject, selecting a pose and composition, seeing the image flattened on the plane, and drawing the flattened image onto paper using the concept of shared edges—the process will become more familiar to you and will be more smoothly integrated.

Drawing by Grace Kennedy.

Drawing by Brian Bomeisler.

EXERCISE II DRAWING YOUR HAND HOLDING AN OBJECT

EXERCISE 12

Drawing a Flower

Materials:

#2 writing and #4B drawing pencils, sharpener, and eraser

Picture Plane/Viewfinder

Felt-tip marker

Fresh flower (or a silk flower, if necessary), with the stem and a few leaves

Time needed:

15 to 20 minutes

Purpose of the exercise:

This drawing will show you the beauty of simple pencil lines on ungrounded paper. You will be drawing a flower with its stem and leaves. Flowers, of course, are three-dimensional, and the leaves are arranged in different directions around the stem. How to portray this three-dimensionality often mystifies students. As you have seen with your hand drawings, however, using the picture plane is the key to realistically depicting this beautiful form on paper. Paradoxically, you must first flatten the form in order to depict its true volume as a three-dimensional form existing in space.

Instructions:

1. Turn to page 45 of the workbook.

2. Lightly draw a set of perpendicular crosshairs into the blank format. From here on, you will be drawing the crosshairs in pencil so that you can erase them later if you wish.

3. Lean the flower against a plain background prop, such as a box or a book covered with white paper. You may also place the flower in a vase if you wish.

4. Hold the Picture Plane/Viewfinder vertically in front of the flower. Close one eye and use your felt-tip marker to draw the edges of the flower, stem, and leaves just as you see them flattened on the plane. Be aware that the line will be somewhat shaky and uncertain.

5. Using your #2 pencil and drawing with a light, thin line, transfer the main points of your plastic plane drawing onto the paper.

6. Set the Picture Plane/Viewfinder to one side. Look closely at each part of the flower, stem, and leaves, and, using your #4B drawing pencil (which is softer than the #2 writing pencil), redraw all of the edges. Remember the lesson of Pure Contour drawing: pay close attention to details and to how the parts fit together to form the whole.

7. Erase the crosshairs if you wish; sign and date your drawing.

Post-exercise remarks:

You have just completed a "line" drawing—that is, a drawing in pure line without shading. Yet, as I am sure you can see, your drawing of the flower appears to be fully three-dimensional, *because you drew the shared edges of your subject just as you saw them on the plane.* Line alone can give your drawing the illusion of three dimensions, and line alone can make a beautiful drawing.

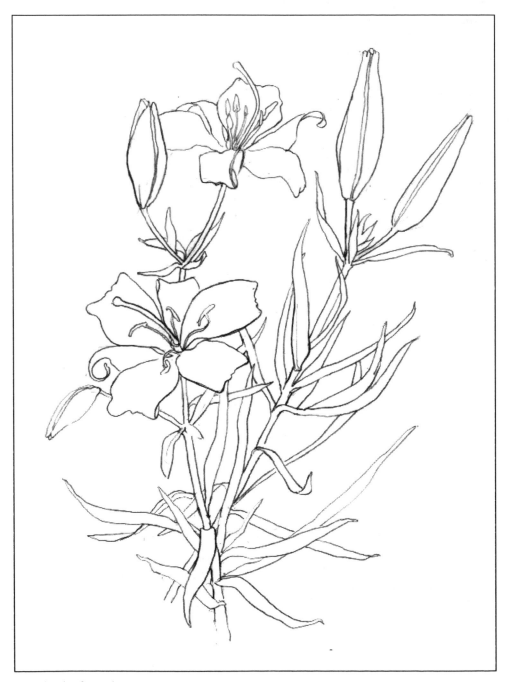

Drawing by the author.

EXERCISE 13
Drawing an Orange

Materials:

#2 writing and #4B drawing pencils, sharpener, and eraser

Picture Plane/Viewfinder

Felt-tip marker

An orange, with the peel cut into triangular sections and peeled halfway back (as in the example drawing)

Sheet of white paper, about 9" x 12"

Time needed:

20 to 30 minutes

Purpose of the exercise:

This exercise gives you further practice in using the Picture Plane to draw a "difficult" view of an object. In this case, you will be drawing a half-peeled orange, with the peels moving in three dimensions.

Instructions:

1. Turn to page 48 of the workbook.

2. Using your #2 pencil, lightly draw crosshairs within the format, dividing the format into four equal quadrants.

3. Set the orange on a piece of white paper. Compose your drawing by holding up the plastic Picture Plane/Viewfinder and moving it back and forth and up and down in front of your setup until the orange, framed by the viewfinder, forms a composition that you like.

4. Using your felt-tip marker, draw the orange on the Picture Plane/Viewfinder. Always remember to close one eye in order to flatten the image.

5. Using the crosshairs to guide you, with your #2 pencil copy the main contours of your plastic plane drawing onto your drawing paper.

6. Set the Picture Plane/Viewfinder aside. Using the orange as your model, refine and revise the drawing by seeing and drawing as many details as possible, recalling the lesson of Pure Contour drawing. If you wish, use your #4B pencil for this detailed drawing. When you find yourself marveling at the beauty of the object you are drawing, you will have made a mental shift to the visual mode.

7. Erase the crosshairs if you wish; sign and date your drawing.

Post-exercise remarks:

The last five exercises have focused on the first component skill of drawing: the perception of edges. By definition, an edge in drawing is a *shared* edge. Recall that by drawing the edge of the face in the Vase/Faces exercise, you simultaneously drew the edge of the vase. Additionally, when you drew your hand, drawing the shapes around the fingernails caused you to inadvertently draw the fingernails. By using edges as they are defined in drawing and by using the concept of the picture plane to draw varying subjects, such as your hand, a flower, and an orange, you are gaining knowledge of *what drawing is and of how to do it.*

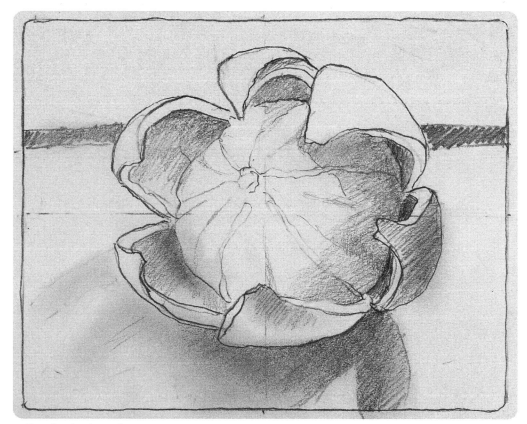

Drawing by the author.

EXERCISE 13 DRAWING AN ORANGE

EXERCISE 14

Drawing Leaves Using Negative Spaces

Materials:

#2 and #4B pencils, sharpener, and eraser

Felt-tip marker

Picture Plane/Viewfinder

Stem of a plant, 10" to 12" tall, with medium-sized leaves (see the drawing for an example)

A sheet of 9" x 12" white paper

Time needed:

About 30 minutes

Purpose of the exercise:

This exercise builds on your new ability to see and draw edges by introducing you to one of the most important skills in drawing: seeing and drawing negative spaces. Negative spaces are important for three reasons:

1. Seeing negative spaces makes it easy to draw difficult views, especially foreshortened views. Negative spaces build on the concept of edges in drawing as shared edges: if you draw the negative spaces around a fore-shortened form, you will have inadvertently also drawn the form, and you will find that it is drawn correctly.

2. An emphasis on negative spaces strengthens and improves the unity of your compositions.

3. Focusing on negative spaces causes the language mode of the brain to drop out, allowing access to the visual brain mode, which is suited to the task of drawing. When you focus on an "empty" space, the language mode seems to say, in effect, "I do not deal with nothing." It takes a moment for a negative space to "pop" into focus as a shape. This increment of time may be the language mode objecting, "What are you looking at? I can't name that. If you are going to gaze at nothing, I'm dropping out." Perfect. Just what we want.

Instructions:

1. Turn to page 51 of the workbook, with the printed format.

2. Lightly draw the crosshairs with your #2 pencil.

3. Lay the stem with leaves on a piece of white paper and cover it with your plastic Picture Plane/Viewfinder.

4. Rather than thinking of drawing a leaf, look at the white shapes surrounding the leaves. Focus on one of those shapes and begin to draw that first "negative space." Then draw an adjacent negative space.

5. "Copy" all of the white spaces onto your paper. Do not draw the leaves at all, but be aware that in drawing the edges of the negative spaces, you will have inadvertently drawn the edges of the leaves.

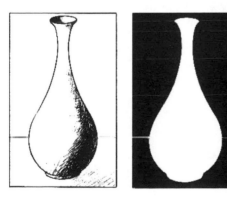

EXERCISE 14 DRAWING LEAVES USING NEGATIVE SPACES

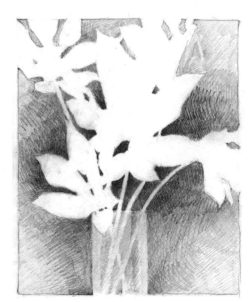

6. Where one leaf crosses another, ignore that edge. Your concern is with the negative spaces only.

7. As in drawing your hand, note where the edges of the white shapes touch the format edges and where they encounter the crosshairs.

8. When you have drawn all of the spaces, use your pencil to fill them in so that the negative spaces are dark and the positive forms (the stem and leaves) are left untouched.

9. Erase the crosshairs if you wish; sign and date your drawing.

Post-exercise remarks:

From the image you have just created, I am sure you can see the power of negative-space drawing. Drawings that emphasize negative spaces are a pleasure to look at, perhaps because the compositions are strong (emphasis on negative spaces always improves composition) and the spaces and shapes are *unified,* meaning that *equal attention* has been paid to both.

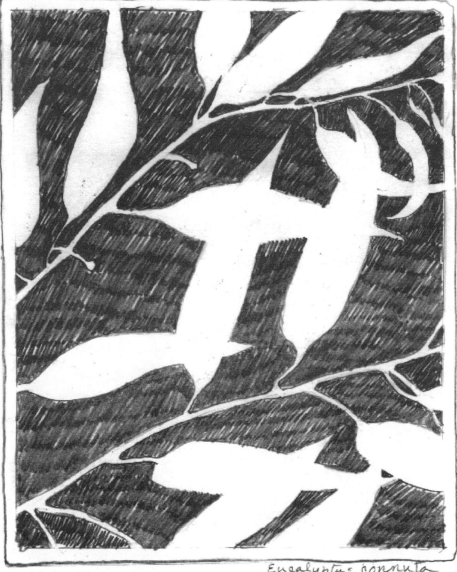

Eucalyptus cornuta

Drawing by the author.

EXERCISE 15

Drawing a Chair in Negative Space

Materials:

#2 pencil, sharpener, and eraser

Picture Plane/Viewfinder

Felt-tip marker

#4B graphite stick and paper towel, for setting a ground

Photograph of a chair, about 5" or 6", cut from a newspaper or magazine advertisement (or use the one on page 54 of the workbook)

Sheet of white paper, 9" x 12".

Time needed:

About 30 minutes

Purpose of the exercise:

One common problem in starting a drawing is deciding *how big to make the first shape.* If you draw the first shape too large, the subject of your drawing will go off the page. If you draw the first shape too small, the subject will sit in the center of the page and you must then deal with the unintended empty surrounding area. Choosing what I call a "Basic Unit" as a starting shape will solve this problem and enable you to end with the composition you intended to draw.

Instructions:

1. Turn to page 55 of the workbook, with the printed format.

2. Lightly draw the crosshairs with your #2 pencil.

3. Set a ground within the printed format, following the directions in Exercise 9.

4. Lay your Picture Plane/Viewfinder over your chair photograph, moving it around until you find a composition you would like to draw.

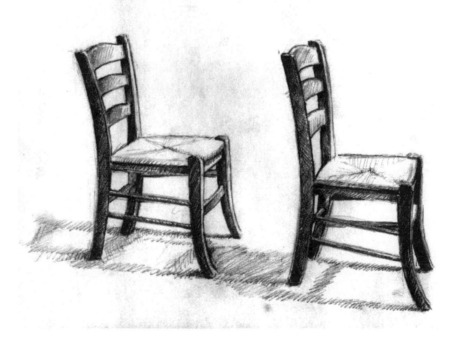

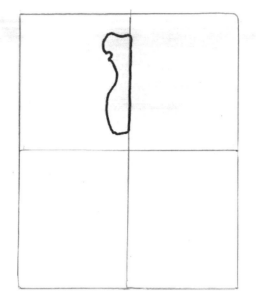

Figure 15-1.

Figure 15-2.

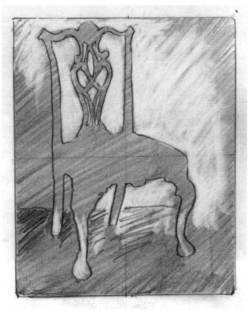

Figure 15-3.

5. Look at the various negative spaces of the chair. Choose one to use as a Basic Unit or starting shape. The shape should be roughly medium in size compared to the other negative spaces—neither too large nor too small. You need a manageable unit of a simple shape. See Figure 15-1 for an example.

6. With your felt-tip marker, draw the shape of that space onto the plastic Picture Plane/Viewfinder.

7. Place the Picture Plane/Viewfinder on a sheet of white paper so that you can see the shape you have drawn.

8. With your #2 pencil, copy that shape onto your toned format, using the crosshairs to guide the size and placement. See Figure 15-2.

9. Set the Picture Plane/Viewfinder aside and begin to draw the remaining negative spaces of the chair by referring to the photograph. Make sure that you size and shape all of the spaces in relationship to the Basic Unit. In this way, you will end with the composition you chose in the first place. See Figure 15-3.

10. When you have finished drawing the negative spaces, use your eraser to remove the tone of either the spaces or the chair itself.

11. Erase the crosshairs if you wish; sign and date your drawing.

Post-exercise remarks:

This exercise in using a Basic Unit is the key to starting drawings. If you have a chance to watch a professional artist work, it might seem to you that the artist "just starts drawing." On the contrary, by the time an artist makes the first mark on the paper, the subject has been scanned and the Basic Unit has been mentally chosen. The artist then locates the Basic Unit within the format, perhaps with some quick hand movements over the paper (sometimes called "phantom" drawing), in order to ensure the correct sizing and placing of the Basic Unit within the format. It happens so fast, however, that it seems to someone watching that the artist just starts drawing.

In the exercises to come, if choosing a Basic Unit seems slow and somewhat tedious to you, remember that with practice the process will soon become automatic and very rapid. Then, you will no longer need the plastic Picture Plane/Viewfinder or the marker. The process will be entirely mental, and someone watching you will think that you "just start drawing."

The Basic Unit also demonstrates that drawing, in its own way, is beautifully logical in its spatial aspects. When the spaces and shapes are drawn just as they appear on the picture plane and in correct relationship to the Basic Unit, they fit together in a logical relationship that seems satisfying and fascinating. To me, this is one of the delightful aspects of drawing.

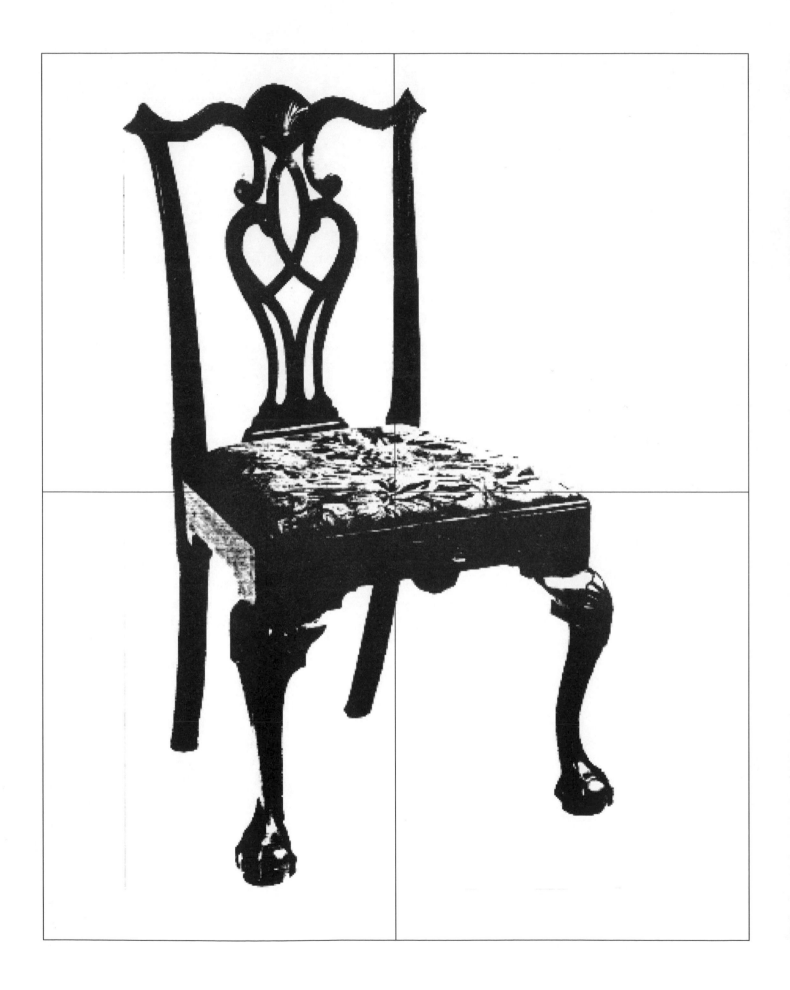

EXERCISE 15 DRAWING A CHAIR IN NEGATIVE SPACE

EXERCISE 16

Drawing a Household Object

Materials:

#2 and #4B pencils, sharpener, and eraser

Picture Plane/Viewfinder

Felt-tip marker

A household object, such as a corkscrew bottle opener, eggbeater, whisk, scissors, or any gadget that appeals to you.

Time needed:

About 20 minutes

Purpose of the exercise:

This exercise provides further practice in using both negative spaces and the Basic Unit in order to help "set" these skills. You will be drawing on an ungrounded paper, to again demonstrate the beauty of pencil line on paper.

Instructions:

1. Turn to page 58 of the workbook, with the printed format.

2. Lightly draw the crosshairs in the format with your #2 pencil.

3. Set your chosen object in front of you, propping it upright if you wish.

4. Hold your Picture Plane/Viewfinder up in front of the object. Now, close one eye and move the Viewfinder around until you find a composition you like. Choose a negative space to use as a Basic Unit. This can be, for example, a space in the handle of the scissors, a space between the wires of the whisk, or the space between the handle and arm of a corkscrew bottle opener.

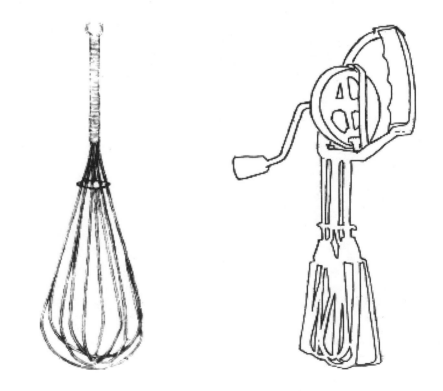

5. Holding the Picture Plane/Viewfinder as steadily as possible, use your felt-tip marker to draw your Basic Unit on the plastic plane.

6. Using the crosshairs to guide you, use your #2 pencil to transfer your Basic Unit to your format on the paper.

7. Set aside the Picture Plane/Viewfinder. Now draw the rest of the negative spaces of the object, using either your #2 or #4B pencil. The #2 pencil produces a thin, light line; the #4B, a wider, darker line. Be sure to close one eye to remove binocular vision, so that you can see the object as though it were flattened on the plane.

8. Continue until you have drawn all of the negative spaces, thus drawing the object itself.

9. Erase the crosshairs if you wish; sign and date your drawing.

Post-exercise remarks:

One of the striking characteristics of negative-space drawings is that no matter how mundane your subject—a chair, a bottle opener, an egg-beater—your drawing will seem somehow beautiful and *significant*. This demonstrates, I believe, the power and importance of negative spaces in art. When you look at classic artworks in museums or in books on art, I guarantee that you will see strong emphasis on negative spaces over and over again.

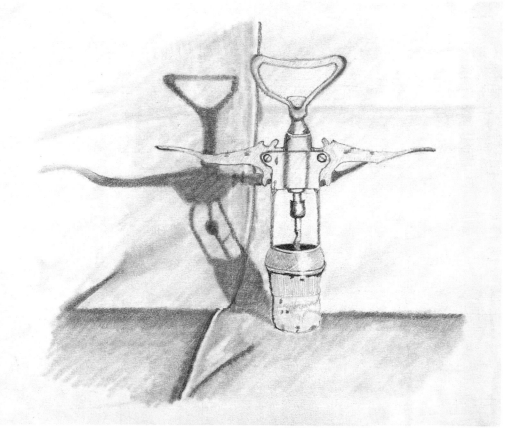

Drawing by student Kenneth McLaren.

EXERCISE 16 DRAWING A HOUSEHOLD OBJECT

EXERCISE 17

Negative-Space Drawing of a Sports Photograph

Materials:

#2 and #4B pencils, sharpener, and eraser

Picture Plane/Viewfinder

Felt-tip marker

A sports photograph from a newspaper or magazine, preferably one that includes a foreshortened view of an athlete, and preferably one as large or larger than the opening of the Picture Plane/Viewfinder

Time needed:

About 30 minutes

Purpose of the exercise:

The five component perceptual skills of drawing—seeing edges, spaces, relationships, lights and shadows, and the gestalt—apply to every drawing, no matter what the subject matter. For the purpose of these exercises, we are taking up these skills one by one.

In this exercise, the emphasis is again on negative spaces, with the subject this time a sports figure. The purpose is to demonstrate that foreshortening in figure drawing—one of the truly difficult aspects of learning to draw—is made easy by shifting from the foreshortened forms to the negative spaces around them. We are using a sports photograph because such photographs very often include foreshortening and are readily available in everyday newspapers (whereas finding a model to pose for you in a foreshortened position can be quite difficult).

Instructions:

1. Turn to page 61 of the workbook, with the printed format.

2. Lightly draw the crosshairs within the format with your #2 pencil.

3. Lay your Picture Plane/Viewfinder over the sports photograph, moving the plane around until you find a composition you like.

4. Choose a negative space to use as a Basic Unit—perhaps the space between the arm and body of a figure, or between the figure and the edge of the format. The shape should be of medium size and as uncomplicated as possible.

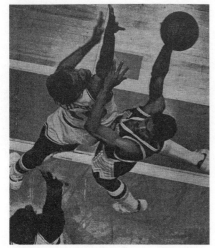

Photograph by Joe Kennedy

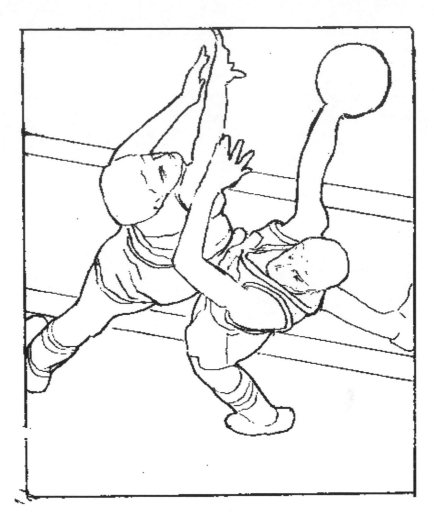

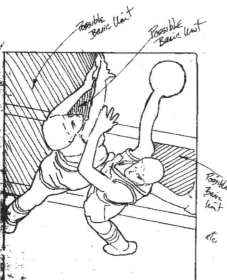

5. Draw the Basic Unit on the plastic plane with your felt-tip marker.

6. Transfer the Basic Unit to your format.

7. Continue to draw the negative spaces (thus inadvertently drawing the outside edges of the athlete).

8. If you wish, draw the shapes within the figure (edges of clothing, helmet, and so on) until you are satisfied that the drawing is complete.

9. You may want to add some lights and shadows, but your negative-space drawing will stand on its own as a beautiful line drawing.

10. Erase the crosshairs if you wish; sign and date your drawing.

Post-exercise remarks:

Looking at your completed drawing should help you realize how seeing and drawing negative spaces makes drawing easy. Because edges in drawing are shared edges, drawing negative spaces around the positive forms gives you the difficult forms—the foreshortened views of forms—without your having to draw them. Drawing foreshortened forms is always problematic, because we all have preconceived, memorized information and symbols for forms—human arms and legs, for example. Foreshortened views contradict that information and thus are difficult to see and draw as they appear on the picture plane. On the other hand, we have no preconceived, memorized symbols for negative spaces, and therefore it is easy to see and draw them. This is one of the important secrets of drawing.

EXERCISE 18

Negative-Space Drawing of an Actual Chair

Materials:

#2 and #4B pencils, sharpener, and eraser

Graphite stick and paper towel for setting a ground

Picture Plane/Viewfinder

Felt-tip marker

Chair of any shape or size

Time needed:

30 to 40 minutes

Purpose of the exercise:

Drawing an actual chair, as opposed to a photograph of a chair, is a good way to summarize all the skills you have learned so far. In a photograph, the image is already flattened. In drawing a real chair, which exists in three-dimensional space, you will call on all of the previous exercises. First, you must flatten the image by viewing it on the Picture Plane/ Viewfinder and close one eye to remove binocular vision. Then, you will choose a Basic Unit from the negative spaces you see on the picture plane. Using the concept of shared edges, you will draw the negative spaces just as you see them on the Picture Plane/Viewfinder, confident that you are simultaneously drawing the edges of the chair.

Instructions:

1. Turn to page 65 of the workbook. Set a ground in the printed format.

2. Lightly draw the crosshairs in the format using your #2 pencil.

3. Set up your model: a chair.

4. Hold your Picture Plane in front of your face to choose your composition. Move the Picture Plane backward, forward, and from side to side, as though you were composing a photograph. The chair should almost fill the Viewfinder, so that it will take up most of the format when you draw it on your paper.

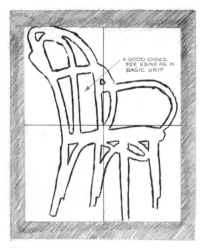

Figure 18-1.

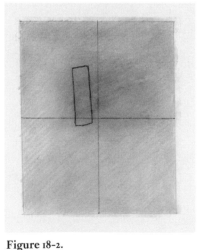

Figure 18-2.

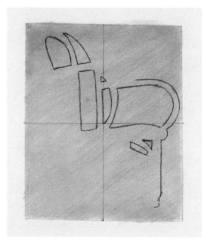

Figure 18-3.

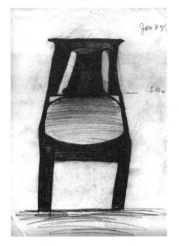

A student's uninstructed drawing of a chair.

5. Choose a medium-sized negative space to use as a Basic Unit—for example, a space between the slats of a chair back or a space between rungs. Next, use the felt-tip marker to draw your Basic Unit on the Picture Plane/Viewfinder. See Figure 18-1.

6. Use your #2 pencil to transfer the Basic Unit to your toned paper. See Figure 18-2.

7. Draw the negative spaces adjacent to your Basic Unit, remembering to close one eye to flatten the three-dimensional image of the chair. See Figure 18-3.

8. Work from part to part, negative space to positive shape, putting the drawing together like a jigsaw puzzle. See Figure 18-4.

9. When you have completed the negative spaces, begin to work on the chair itself and its surrounding space. You can erase out or darken any highlights or shadows. See Figures 18-5, 18-6, and 18-7.

10. Prop your drawing up and step away from it a bit to see it from a fresh point of view. Make any changes that you feel are needed.

11. Erase the crosshairs if you wish; sign and date your drawing.

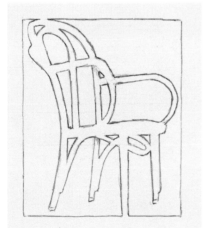

Figure 18-4.

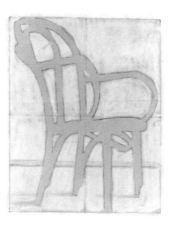

Figure 18-5.

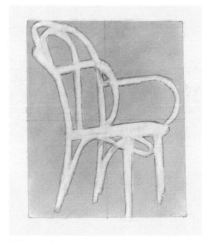

Figure 18-6.

Post-exercise remarks:

Congratulations on completing a very difficult drawing. Chairs are such familiar objects that we carry in our minds hard-to-erase visual symbols for chairs that we have memorized from childhood drawing. For example, we *know* that chair legs are all the same length. In the Picture Plane flattened view, however, each chair leg may have *appeared* to be a different length, and you may have had trouble accepting that perception. Paradoxically, if you drew the chair legs just as you saw them on the plane, they will appear to the viewer of your drawing to be appropriately all the same length. This is the magic of drawing.

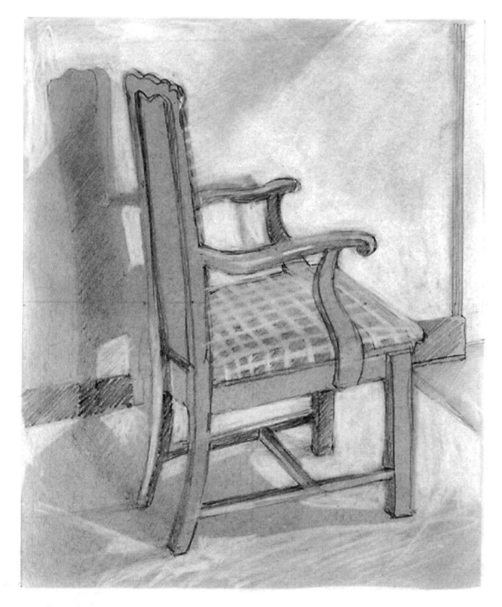

Figure 18-7. Drawing by the author.

EXERCISE 19

Copying a Master Drawing: *Man Reading the Bible,* by Vincent van Gogh

Materials:

#2 and #4B pencils, sharpener, and eraser

The reproduction of the Van Gogh drawing on page 68

Time needed:

45 minutes to 1 hour

Purpose of the exercise:

During and after the decades of Abstract Expressionism, a school of painting originating in New York in the 1940s, copying masterworks was out of favor as a way of training artists in America. Now, however, new appreciation of drawing skills is bringing the practice back into art schools. Copying master drawings is an excellent way to practice your drawing skills, and you will learn a great deal from copying this wonderful artwork.

Note that the format of *Man Reading the Bible* (the proportions, width to length, of the outside edge) is slightly different from the one you have been using, and different from the format of your Picture Plane/ Viewfinder. Whenever you copy a drawing, *make sure that the proportions of the format are the same.* Your drawing format can be a different size, but it must be in the same proportions. If you think it through, you will see why. The spaces and shapes fit together to fill the format: if you were to use a different format for this drawing—say, a square—neither the shapes nor the spaces could match the original.

Instructions:

1. Turn to page 69 of the workbook, with the printed format in the same proportions as the original drawing.

2. You may want to lightly draw crosshairs on the original drawing and on your format, measuring carefully to make sure the crosshairs fall at the midpoints of the drawing. This will help you to keep your copy in proportion by seeing where the various points fall.

3. You may want to turn this drawing upside down to make a start. Whether it is right side up or upside down, begin by drawing the negative spaces around the seated man and chair.

4. Use the concept of negative spaces *within* the figure as well. For example, the shape between the man's two forearms can be seen and drawn as an "interior negative shape." The shape of his lower right trouser beneath his left hand can also be seen and drawn as an interior negative shape.

5. Check the angles of the negative spaces of the chair rungs relative to the horizontal and vertical edges of the format and crosshairs. As you progress, check each space and each shape to see if you have matched the original.

6. Use your #4B pencil to darken the shadow shapes of the vest and trousers. You may want to turn the Van Gogh drawing upside down to better see the shapes of the shadows.

7. Erase the crosshairs if you wish; sign and date your drawings. Because it is a copied drawing, be sure to designate it as "After Van Gogh."

Post-exercise remarks:

Even though you have copied a master drawing in this exercise, when you look at your work you will notice that your own style of drawing has inevitably shone through. The same was true when Van Gogh himself copied master drawings: his distinctive style always shone through.

One of the wonderful things about the Van Gogh drawing is the distribution of lights and shadows. See, for example, how the shapes of the lights and shadows on the lower left leg reveal the shape of the folded cloth *and* the leg underneath. The experience of copying this drawing will help you in the later light/shadow exercises.

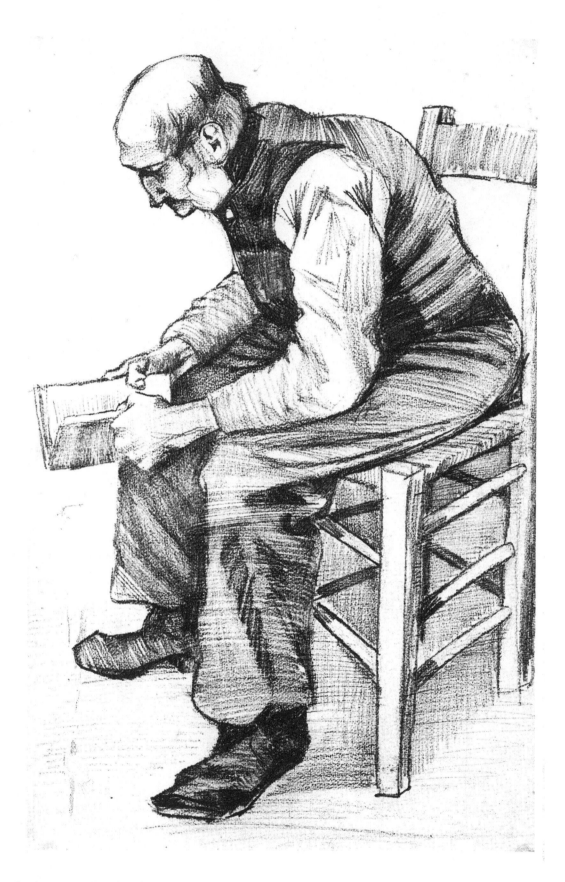

**Vincent van Gogh, *Man Reading the Bible*, 1882.
Collection: Kröller Müller Museum, Otterlo,
the Netherlands.**

EXERCISE **20**

Sighting an Open Doorway

Materials:

#2 and #4B pencils, sharpener, and
eraser

Picture Plane/Viewfinder

Felt-tip marker

Time needed:

About 30 minutes

Purpose of the exercise:

In this exercise you will practice the third component skill, the
perception of relationships, also called "sighting." This is a two-part
skill: sighting angles relative to vertical and horizontal, and sighting sizes
relative to each other. Commonly known as "perspective and pro-
portion," sighting has been the Waterloo of many an art student.
It is a complicated skill, both to learn and to teach, but the Picture
Plane/Viewfinder is extremely effective in clarifying how to see and
draw relationships.

 You will use your pencil as a sighting tool, just as artists have been
doing for centuries. Look at the accompanying sketches to see how to
do this. Practice by holding your pencil *at arm's length with your elbow locked
to establish a constant scale,* closing one eye, aligning the blunt end of your
pencil with the horizontal top edge of a doorway, and placing your
thumb to mark the other edge of the doorway (see Figure 20-1). This
measured width is your Basic Unit, or "1." Now, keeping your thumb in
the same position, turn the pencil to vertical and find the relationship

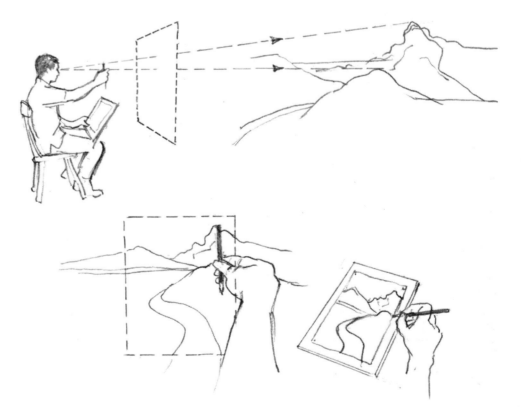

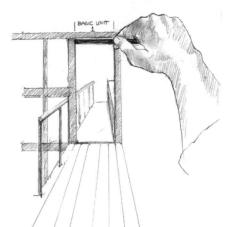

Figure 20-1.

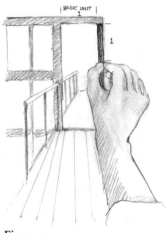

Figure 20-2.

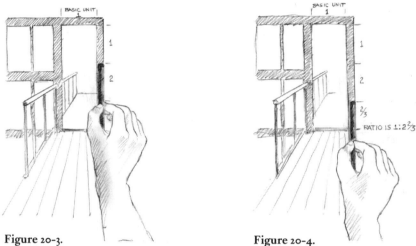

Figure 20-3.

Figure 20-4.

(the ratio or proportion) of width to height of the doorway. See Figures 20-2 , 20-3 , and 20-4. In the sketches, the ratio is "One (Basic Unit) to one and two-thirds," expressed as 1:1⅔. You will transfer this ratio into your drawing by using your pencil to measure your Basic Unit *in your drawing*, then repeating the measuring of the vertical edge of the doorway in the drawing, and drawing the vertical edge. See Figures 20-5, 20-6, and 20-7.

Your pencil is also your sighting tool for determining angles. Angles are sighted relative to vertical and horizontal. To practice, hold your pencil perfectly horizontally with both hands, close one eye, and compare an angle in a corner of the room you are in with horizontal. See Figure 20-8. *Remember* the angle and draw it on your paper using the horizontal crosshairs and the horizontal edges of the format as

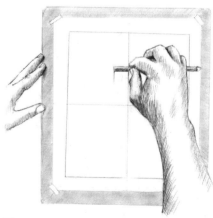

Figure 20-5.

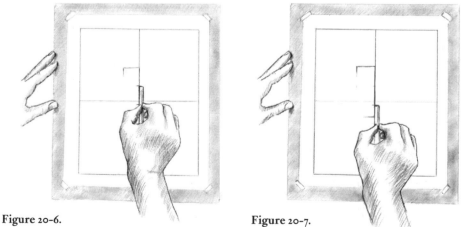

Figure 20-6.

Figure 20-7.

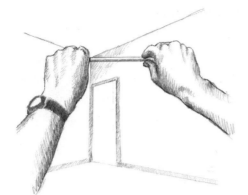

Figure 20-8.

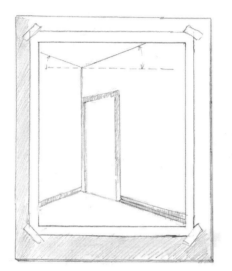

Figure 20-9.

guides to drawing the angle you saw in the room corner. See Figure 20-9.

Be sure you stay *on the plane* in taking sights. Your sighting pencil always stays on the surface of the imaginary glass picture plane. Just as receding edges lie flat on the face of a photograph, the image you are drawing lies flat on the picture plane. You cannot "poke through" the plane to take a sight on a receding edge. See Figures 20-10 and 20-11.

Instructions:

1. Turn to page 74. The format will be left untoned, as this will be a line drawing.

2. Choose a site for your drawing—an open doorway leading into another room or into a closet, or a door open to the outside. See the example drawings for ideas.

3. Seat yourself in front of the site. Use your Picture Plane/Viewfinder to find a composition you like. See Figure 20-12.

4. Hold the Picture Plane as steadily as possible and choose a Basic Unit. I suggest you use the shape of the doorway.

5. Use your felt-tip marker to draw the Basic Unit on the plastic plane. If you wish, you can also draw some of the main edges, such as the ceiling angles or the floor angles, but be aware that the line will be very shaky, and it is easy to make errors in the drawing. All you really need is the Basic Unit.

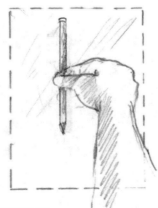

Figure 20-10.

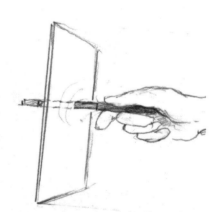

Figure 20-11.

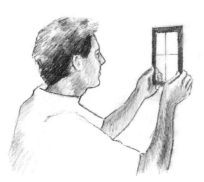

Figure 20-12.

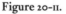
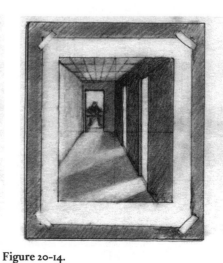

Figure 20-13.

Figure 20-14.

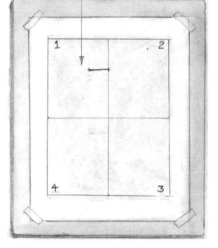

6. Transfer the Basic Unit to your format. See Figure 20-13.

7. Using your pencil as a sighting tool, begin to sight the angles and pro-portions of the doorway and the surrounding walls, floor, and ceiling. Draw in all of the most important edges: the edges of the doorway, the open door, and the edges where the walls meet the ceiling and where the walls meet the floor. Do not forget to emphasize negative spaces wherever possible, especially for small forms like door handles, light fixtures, and potted plants. See Figure 20-14.

8. If any area of the drawing doesn't quite "look right," hold up your Picture Plane again, match up the Basic Unit drawn on the plastic with the doorway, and compare the angles or proportions you see on the plane with your drawing. Make any necessary corrections and complete the drawing.

9. Erase the crosshairs if you wish; sign and date your drawing.

Post-exercise remarks:

You have just completed a drawing that many university art students would find daunting. Sighting angles and proportions is a complicated skill, requiring that you learn first how to "take sights" and then how to transfer them to your drawing. Once learned, the skill quickly becomes automatic, and you will be taking sights without having to remind yourself how to do it at every step.

Every global skill seems to have a component similar to sighting relationships in drawing—for example, learning grammar in writing, learning the rules of the road in driving, learning musical notation, learning the rules of the game in chess. These components seem difficult and much too complicated at first, but later they become automatic and provide the structure needed to practice the skill.

Sighting relationships is required in every drawing and for every subject. Because of its complexity, student often leave sighting unlearned or half-learned, ensuring that they will make errors in their drawings that they will not know how to correct. Sighting relationships is well worth the effort to learn and becomes surprisingly enjoyable once learned.

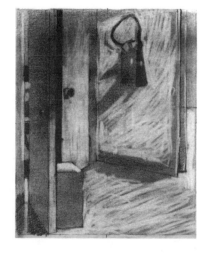

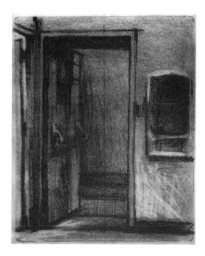

EXERCISE 20 SIGHTING AN OPEN DOORWAY

EXERCISE **21**

Sighting a Room Corner

Materials:

#2 and #4B pencils, sharpener, and eraser

Picture Plane/Viewfinder

Felt-tip marker

Graphite stick and paper towel for setting a ground

Time needed:

30 to 40 minutes

Drawing by Grace Kennedy.

Purpose of the exercise:

For this exercise, choose a room corner that is complicated by including a bed or sofa, tables, lamps, and curtains. Alternatively, choose a corner of your kitchen, with its countertop, cupboards, and appliances. Because this subject is more intricate than the open doorway, this exercise is a good way to demonstrate to yourself how much progress you have made. Remember, however, that realistic drawing (as opposed to abstract, nonobjective, or imaginative drawing) is always the same task, always requiring the same skills. Subjects and mediums vary, but not the basic skills of drawing.

Instructions:

1. Turn to page 77 of the workbook, with the printed format. Set a toned ground and lightly draw in the crosshairs with your #2 pencil.

2. Choose a site that includes furniture or countertops and cupboards.

3. Use the Picture Plane/Viewfinder to choose your composition. Choose and draw your Basic Unit on the plastic with the felt-tip marker. If you wish, *carefully* add a few of the main edges and angles.

4. Transfer the Basic Unit to your toned ground.

5. Check all angles and proportions, using your pencil to "take sights." *Remember, all angles and proportions are sighted on the plane.* Think of the plane as an invisible pane of glass between your eyes and the "model" in front of you.

6. Work from edge to adjacent edge, putting the image of the room corner together like a fascinating jigsaw puzzle. Avoid naming parts as you draw them, and do not forget to emphasize negative spaces.

7. When you have drawn the edges and spaces of the corner, "squint" to see the large shapes of lights and shadows. Erase lighted areas and darken shadowed areas. Step away from your drawing occasionally to view it from a distance and to check for errors.

8. Erase the crosshairs if you wish; sign and date your drawing.

Post-exercise remarks:

Sighting relationships of angles and proportions by the method you are learning is called "informal perspective," as opposed to "formal perspective," which is the method requiring horizon lines, converging lines, and vanishing points. Professional artists are usually trained in both methods, but nearly all use informal perspective when painting or drawing. Formal perspective is simply too cumbersome and unnecessarily complicated for today's artists, and informal perspective, when well practiced, is amazingly accurate.

Many students find even informal perspective drawing painfully difficult at first, but it soon becomes easy and even quite engaging. When friends see your drawing of a room corner, they may ask in amazement, "How did you *do* that?" Your reply might be, "I've just discovered I have some talent for drawing"—after which you can tell your friends how you really did the drawing! You may be interested to compare your just-completed perspective drawing with your pre-instruction drawing from Exercise 3. I feel confident that you will be pleased with your progress.

Drawing by Lizbeth Fermin.

EXERCISE **22**

The Knee/Foot Drawing

Materials:

#2 and #4B pencils, sharpener, and eraser

Picture Plane/Viewfinder

Felt-tip marker

Time needed:

20 to 30 minutes

Purpose of the exercise:

Sighting relationships of angles and proportions is needed for every drawing, not just drawings of buildings and interiors. This exercise provides excellent practice for seeing and drawing edges, spaces, and relationships, the first three component skills of drawing.

Instructions:

1. Turn to page 80 of the workbook. Leave the format untoned and lightly draw the crosshairs.

2. Use the Picture Plane/Viewfinder to choose a view of your own knee and foot, of your feet, or of one foot, with or without shoe(s).

3. Use your felt-tip marker to draw the main negative spaces and edges on the plastic plane.

4. Use a pencil to transfer the main edges to your paper, using the crosshairs to guide you.

5. Set the Picture Plane to one side, in a spot where you can still see it. Complete the drawing, checking back to the Picture Plane if necessary. The size change from the knee to the foot seems incredible, but double-check it: the foot in this perspective view really is that small! If you draw the proportions *just as they appear flattened on the plane,* they will look correct when the drawing is finished.

Drawing by charlotte Doctor.

Drawing by student Bob Jean.

6. Be sure to emphasize negative spaces as you work on the drawing. Shoelaces, for example, are beautiful when drawn using the negative spaces in and around the laces.

7. Erase the crosshairs if you wish; sign and date your drawing.

Post-exercise remarks:

This is one of the best exercises for convincing students to accept their perceptions without second-guessing. The struggle to accept a sighting that contradicts stored knowledge can be difficult. I have watched students repeatedly take sights on an angle or proportion that they questioned. Sometimes I hear them say to themselves, "It can't be," and they check the sight again and again until they finally accept it. Then, on seeing that the questionable proportion or angle made their drawing look right, they find it easier to accept the next questionable sighting. This is one of the most important lessons in drawing: to see, accept, and draw just what you see on the plane.

Drawing by student Ernest Kirkwood.

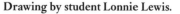

Drawing by student Lonnie Lewis.

Drawing by student Joyce Canfield.

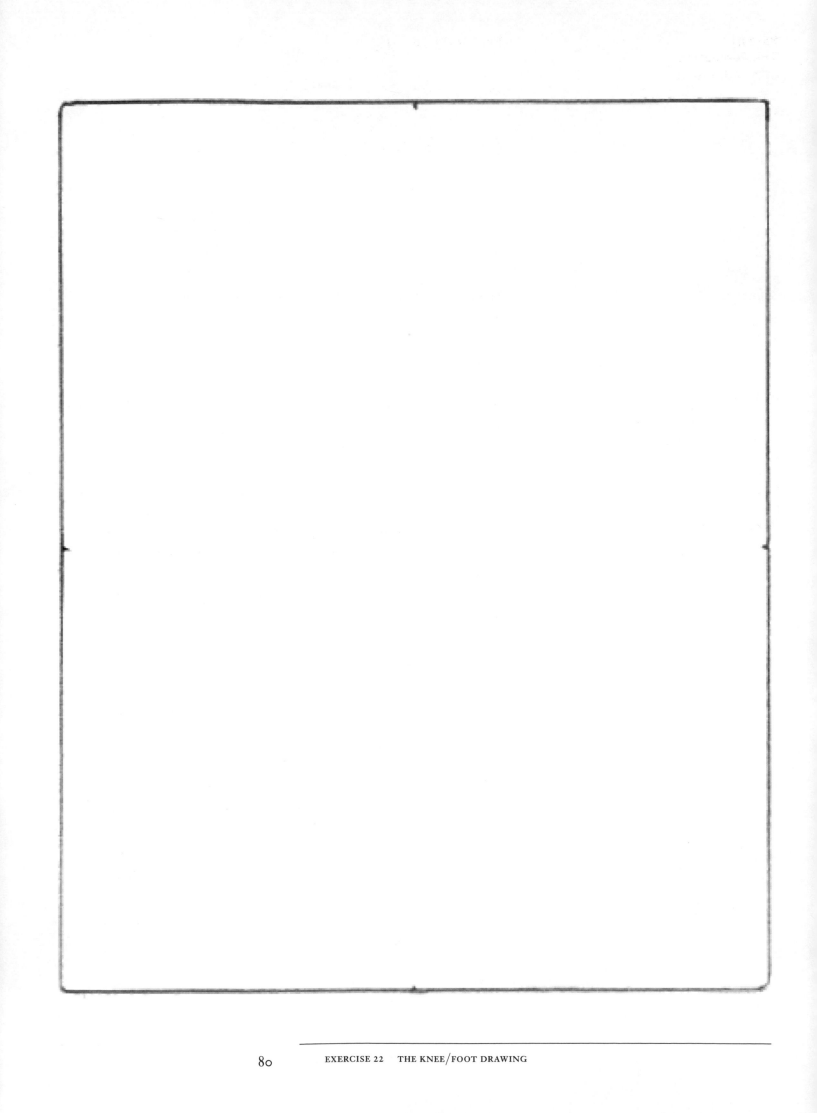

EXERCISE 22 THE KNEE/FOOT DRAWING

EXERCISE 23

Sighting a Still Life of Books on a Table

Materials:

#2 and #4B pencils, sharpener, and eraser

Picture Plane/Viewfinder

Felt-tip marker

Graphite stick and paper towel for setting a ground

Several books, spread at random on a table

Time needed:

About 30 minutes

Purpose of the exercise:

Because you are so familiar with what the shape of a book looks like, it can be hard to accept the apparent shape changes that occur when you draw books that are lying flat on a table and receding from your plane of vision. In certain positions, and at certain angles, a book lying flat on a table may appear on the picture plane to be impossibly narrow or impossibly short. The hard part of this exercise is to draw books lying on a table in the unexpected shapes that they present *when seen on the picture plane.*

Instructions:

1. Turn to page 83 of the workbook, with the printed format. Tone the ground to a pale tone and lightly draw the crosshairs with your #2 pencil.

2. Use the Picture Plane/Viewfinder to find a composition you like and choose a Basic Unit—either a negative space between two books or a positive form (one of the books).

3. Hold the Picture Plane/Viewfinder as steadily as possible, and with the felt-tip marker draw your Basic Unit on the plastic plane.

4. Using the #4B pencil, transfer the Basic Unit to your drawing paper.

5. Set the Picture Plane aside and work from shape to adjacent space, putting the drawing together like a puzzle. Remember to close one eye to flatten the image.

6. Pause every once in a while to check the shapes of the books on the Picture Plane/Viewfinder.

7. Look for the shapes of lights and shadows by squinting your eyes to mask out fine detail. Erase out the lighted shapes and darken the shadowed areas with your #4B pencil.

8. When you are finished, erase the crosshairs if you wish, then sign and date your drawing.

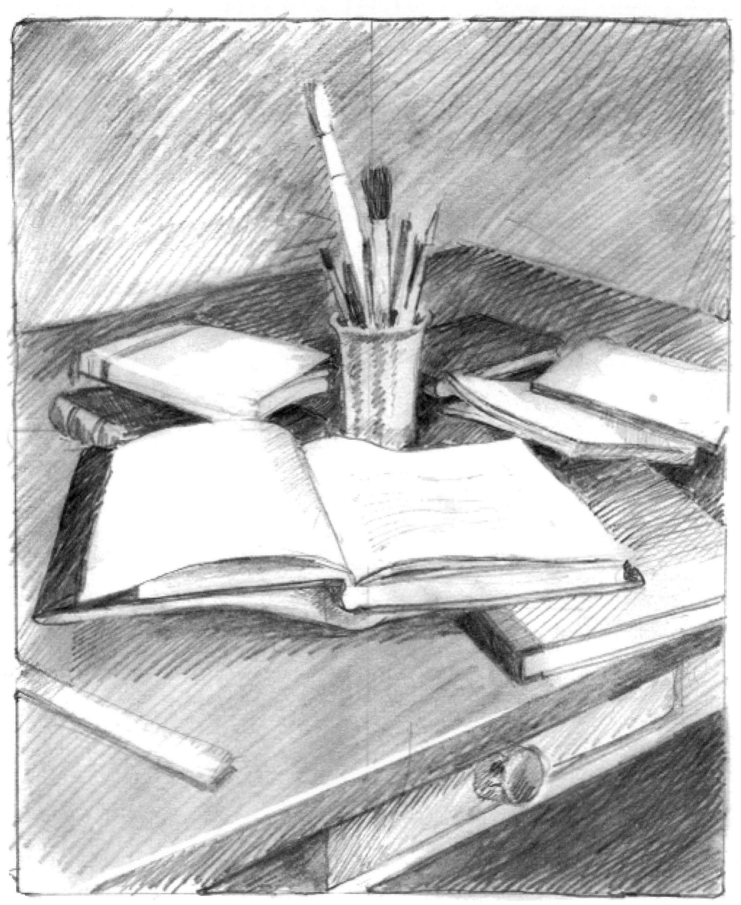

Drawing by the author.

EXERCISE 24

A Still Life with Ellipses

Materials:

#2 and #4B pencils, sharpener, and eraser

Picture Plane/Viewfinder

Felt-tip marker

Still-life setup: The breakfast table is always a good still life, or you may wish to set up a teapot, a cup and saucer, and a glass half-filled with water. Any objects with circular tops will provide ellipses for your still life.

Time needed:

30 to 40 minutes

Purpose of the exercise:

An ellipse is an oval shape, like a stretched-out circle with slightly flattened sides. When you look at a circular object, such as a coin, with one eye closed, it appears to be not circular but elliptical in shape when tilted at an angle relative to the picture plane. When you increase the angle, the ellipse changes shape until the object appears to be a flat shape. This "perspective of ellipses" often seems baffling to students, because, again, the shape seen on the picture plane contradicts what we know about circular shapes.

Ellipses play an important role in drawing still lifes, landscapes, and drawings involving architecture. This exercise, therefore, focuses on ellipses. As always, the solution is to draw them just as you see them flattened on the plane.

Instructions:

1. Turn to page 86 of the workbook, with the printed format. If you wish, lightly tone the paper before you add the crosshairs.

2. Use your Picture Plane/Viewfinder to choose a composition.

3. Hold the Picture Plane/Viewfinder as steadily as possible and choose a Basic Unit (perhaps one of the objects in your still-life setup).

4. Using your #4B pencil, transfer the Basic Unit to your paper.

5. Remember to close one eye when drawing the ellipses of the tops (and bottoms!) of cups, glasses, and plates. Try to see them as shapes, or, better still, *see the shapes of the negative spaces* surrounding the ellipses.

6. As always, work from shape to adjacent space, putting the parts together like a puzzle. If you started with a cup, for example, check the negative space next to the cup. That space will be bounded by the edge of the next object. Draw that object and move to the next space.

7. As you are drawing, be sure to step away a few times and check to see that the perspective and proportion "look right." If something seems off, hold up the Picture Plane/Viewfinder, match up the Basic Unit on the Viewfinder with the object, and then look at the areas causing problems.

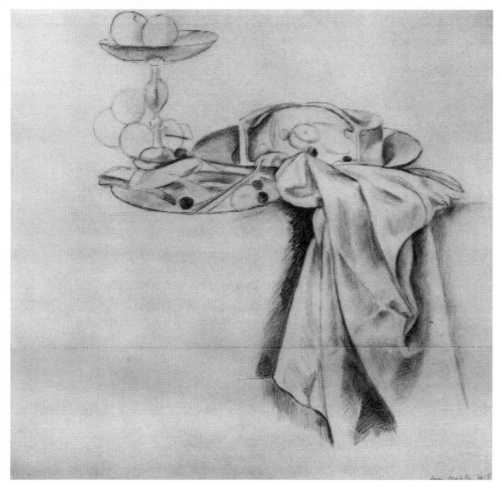

Henri Matisse. *Study for Still-life after de Heem*, 1915. **Graphite on two sheets of paper. 20⅛ x 21¼ inches. Philadelphia Museum of Art. The Louise and Walter Arensberg Collection.**

Compare what you see on the Viewfinder with what you have drawn. If what you have drawn does not match what you see on the picture plane, make the corrections.

8. Erase the crosshairs if you wish, then sign and date your drawing.

Post-exercise remarks:

The most common errors in drawing ellipses are depicting the ellipse ends as too pointed and depicting the upper curve as greater than the lower curve. These errors can be avoided by looking very closely at the shape you are drawing.

Drawing ellipses can be either mind-bendingly difficult or incredibly easy, depending on whether you are able to accept the elliptical shapes as you see them on the picture plane. The ellipses at the bottoms of cups, saucers, and glasses are particularly difficult to see, because you know the objects are resting on a flat surface. A common tendency for beginners is to make a straight line across the bottoms of cups and glasses, presumably so they won't tip over! Shifting to drawing adjacent negative space is extremely helpful in drawing ellipses.

EXERCISE *25*

Sighting Relationships in a Figure Drawing

Materials:

#2 and #4B pencils, sharpener, and eraser

Picture Plane/Viewfinder

Felt-tip marker

Time needed:

About 30 minutes

Purpose of the exercise:

In this exercise, you will see how sighting works in drawing a human figure. You will be copying a sketch of a life-size sculpture of the writer Edgar Allen Poe, which is situated on the campus of the University of Maryland. With the sketch is a diagram of the sights I took to make the drawing.

Instructions:

1. Turn to page 89 of the workbook, where you will find the sketch and diagram of the Poe sculpture. On page 89, you will find a printed format.

2. Using your #2 pencil, lightly draw the crosshairs within the format.

3. Place your Picture Plane/Viewfinder over the sketch. The crosshairs will help guide your copy of the sketch.

4. Use your marker to make a mark at the top of Poe's head and at the bottom of the chin on the plastic Picture Plane/Viewfinder. This is your Basic Unit. Use your #2 pencil to transfer the Basic Unit to your paper. These two marks are all you need to start your drawing on the paper. You will use this Basic Unit in sighting all of the angles and proportions of the figure.

5. Using your #4B pencil, draw the head on your paper, checking the placement of the features relative to the whole head.

6. Now begin to sight the figure:

 a. Sight the angle of the arm against horizontal. Draw the upper edge of the arm.

 b. Sight the length of the arm to the elbow. With your pencil, measure the Basic Unit, then the edge of the arm. The proportion (the ratio of the Basic Unit, which is your "1") to the length of the upper arm is 1:2 (see the diagram). Draw the edge of the upper arm to the elbow.

 c. Sight the angle of the forearm against the horizontal (the ledge is horizontal). Draw that edge and the edge of the ledge.

Instructions continue on page 92.

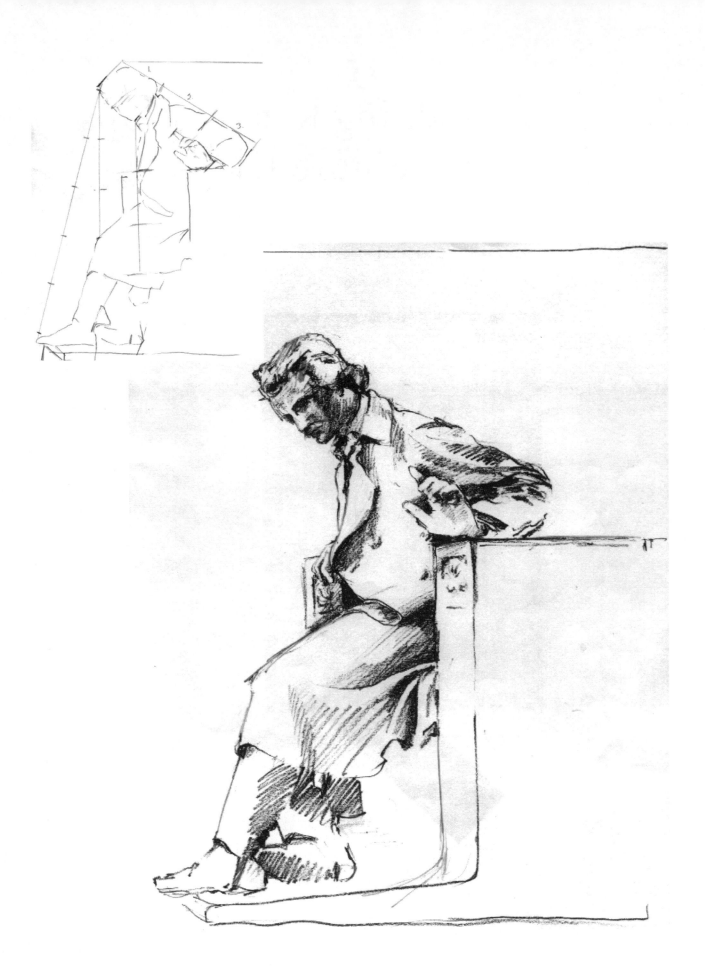

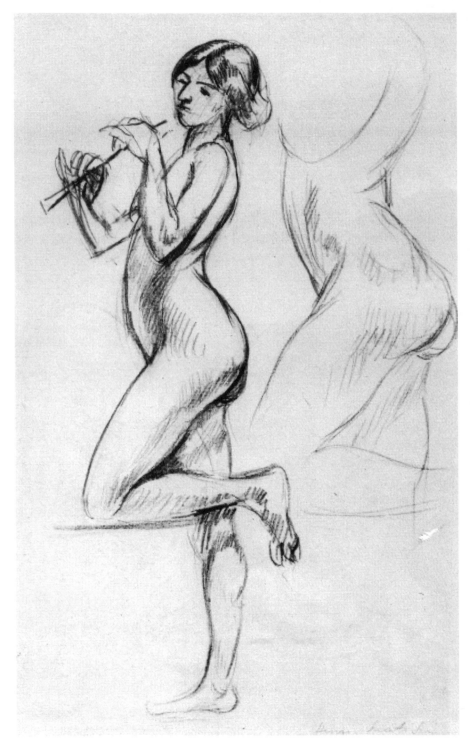

Practice sighting the figure in this drawing.
I suggest using the length of the head as your
Basic Unit. Henri Matisse, *Two Sketches of
a Nude Girl Playing a Flute*. Pencil on white
paper. 13⅝ x 8¼ inches, Fogg Art Museum,
Harvard University, Cambridge, Mass.
Gift of Mr. and Mrs. Joseph Kerrigan.

d. Sight the length of the hand against the Basic Unit. The ratio is 1:1. (Check it twice if you find that hard to believe!) Draw the hand by using the negative shapes around it.

e. Draw the negative space in front of the chest and the shape of the far ledge.

f. Drop a "sight line" (see the diagram) from the front of the head to the point of the knee. Determine how far down that point is by going back to your Basic Unit and checking the ratio to the point of the knee. The ratio is 1:3.

g. Having located that point, check the angle of the upper leg and draw in that edge.

h. Drop another "sight line" to determine where the point of the shoe toe is located, and check the position (the angle relative to vertical). Go back to your Basic Unit, then compare the distance. The ratio is 1:5 and a little bit more.

i. Having located the shoe-toe, use the negative space in front of the lower leg to draw that edge.

j. Sight the length of the shoe against your Basic Unit. The ratio is 1:1⅛. Double-check if you find that hard to believe.

k. Use negative spaces to draw the other shoe, but sight the length. The ratio is 1:1 because the shoe is slightly foreshortened.

l. Finish your drawing by adding shadows and details.

m. Erase the crosshairs if you wish; sign and date your drawing.

Post-exercise remarks:

The sighting process, as you have now experienced it, may seem tedious. Remember, however, that learning any new skill requires slow processing in the early stages. For example, as mentioned earlier, learning the rules of grammar was a complicated task that, when learned, became automatic and indispensable. Sighting, I believe, can be regarded as the "grammar" of drawing. Learning it now will prevent frustrating errors in future drawings. Trust me: sighting will soon become rapid and automatic, enjoyable and easy.

EXERCISE 26

Proportions of the Head in Profile

Materials:

#2 and #4B pencils, sharpener, and eraser

Diagram of the proportions of the head in profile

Blank diagram of the profile head

Note: You will need to ask someone to model for 5 minutes for this exercise.

Time needed:

About 20 minutes

Purpose of the exercise:

The proportions of the human head are very difficult to see clearly. I venture to say that only someone trained in perception or in drawing is able to bypass the brain processes that make these proportions difficult to perceive. For reasons that are unclear, a person untrained in seeing relationships apparently sees the features of the face as being larger in relation to the whole of the head than is actually the case. This exercise will provide scaffolding for seeing the correct proportions.

Instructions:

1. Turn to pages 94 and 95 of the workbook, with the diagram showing the proportions of the head in profile and the head proportion diagram.

2. Working carefully and memorizing as you draw, copy the proportions shown in the printed diagram onto the partially drawn diagram on page 95.

3. Now find someone to act as a measuring model. Ask that person to sit for you for five minutes in profile view. Look carefully at your model's head and features. Then, using a pencil to measure, check every proportion that appears on the diagram, paying particular attention to the proportion "Eye level to chin equals *eye level to the top of the outermost curve of the head,*" and the proportion "Eye level to chin equals *back of the eye* to the back of the ear." These are the two key proportions for successful profile portraits.

Drawing by student Tom Nelson.

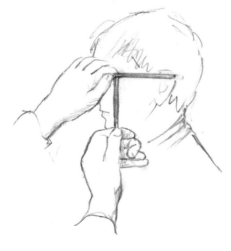

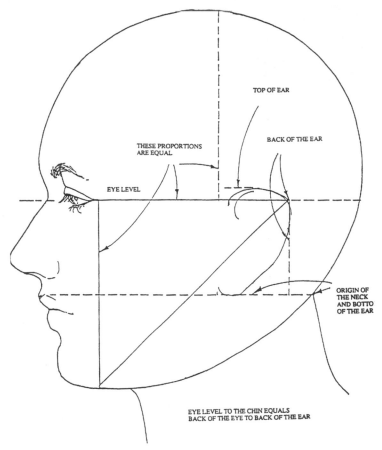

Profile view: General proportions of the head and placement of the ear.

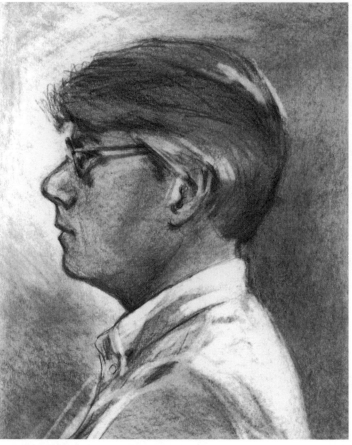

Portrait of Scott by instructor Beth Fermin.

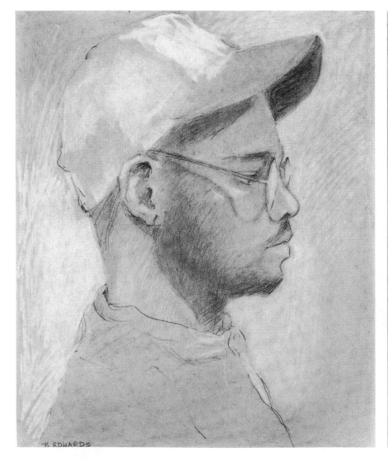

Demonstration drawing by the author.

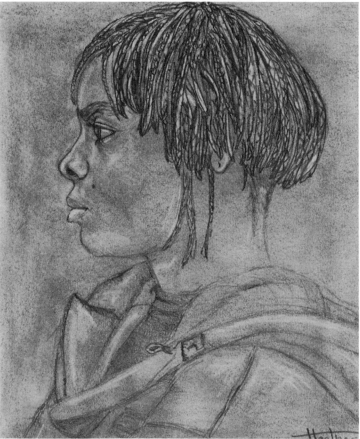

Drawing by student Heather Tappen.

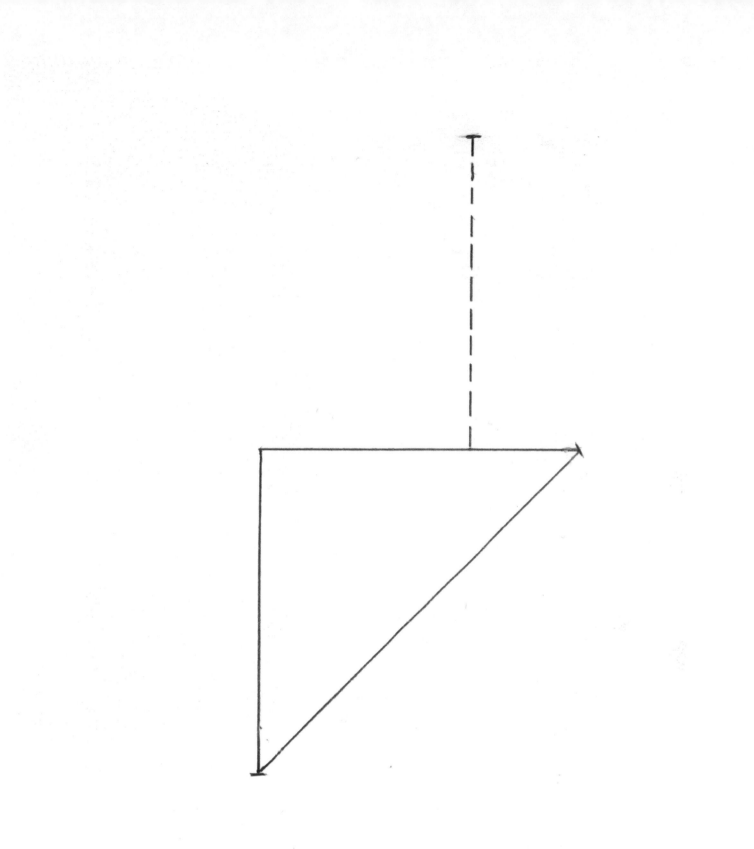

EXERCISE *27*

Copying a Master Drawing of a Profile Portrait

Materials:

#2 and #4B pencils, sharpener, and eraser

Picture Plane/Viewfinder

Time needed:

20 to 30 minutes

Purpose of the exercise:

This beautiful 1883 drawing *Mme. Pierre Gautreau* (also known as *Madame X*), by English artist John Singer Sargent, provides perfect practice for seeing and drawing edges, spaces, and relationships—especially the proportions of the head in profile.

Instructions:

1. Turn to page 98, with the reproduction of the Sargent drawing, and see the accompanying diagram on page 97.

2. On page 99 of the workbook, you will find the printed format.

3. Using a pencil, lightly draw the crosshairs on the format.

4. Lay your Picture Plane/Viewfinder directly on top of the Sargent reproduction and note where the crosshairs fall on the portrait profile.

5. Choose a Basic Unit. I suggest using the length of the nose (from the innermost curve to the outermost tip) for comparing all other proportions in the drawing. For example, the proportion of the nose length to the forehead is the ratio one to one and a half, or 1:1 ½. Make two marks, one at the innermost curve and one at the tip of the nose.

6. Using your #2 pencil, transfer the two marks of your Basic Unit to the paper.

7. I suggest the following sequence of steps, corresponding with the numbered steps in the diagram:

 1. In the upper right quadrant, find the point where the forehead meets the hairline. Double-check it, using your Basic Unit to measure the placement. Mark that point, and use the negative space in front of the forehead to draw the forehead's curve.

 2. You located the tip of the nose when you marked your Basic Unit. Double-check the position of the mark against the crosshairs.

 3. Draw the shape of the negative space in front of the nose/forehead. Recall the concept of shared edges.

 4. Imagine a line that touches the tip of the nose and the tip of the chin in the reproduction drawing. Lightly draw that sight line on your paper, checking the angle against vertical. Compare your Basic Unit

to the length from nose-tip to chin-tip. The ratio is 1:1 ⅓. Mark the tip of the chin on your sight line.

5. Draw the shape of the negative space defined by your sight line. This will give you the shape of the upper lip, the lower lip, and the chin.

6. Relative to the crosshairs, find the innermost curve of the chin/neck. Mark that point on your drawing.

7. Look at the shape of the negative space made by the chin and neck. Draw that shape.

8. Relative to the crosshairs, locate the back of the head and draw the edge.

9. Locate the back of the ear and draw the ear.

10. Locate the back of the neck and draw that edge.

11. Observe how small the eye is relative to your Basic Unit. Draw the eye, locating it relative to the innermost curve of the nose.

12. Draw the eyebrow relative to the eye, checking the curve of the eyebrow by looking at the negative space beneath the eyebrow.

13. Observe the size of the mouth relative to the eye and draw the mouth.

14. Locate the ear relative to the crosshairs and compare the length of the ear to your Basic Unit. Surprisingly, the ratio is nearly 1:1⅓. Draw the ear, checking the negative space behind the ear.

15. Draw the shape of the head and hair.

16. When you are finished, erase the crosshairs. Sign and date your drawing with the notation "After Sargent."

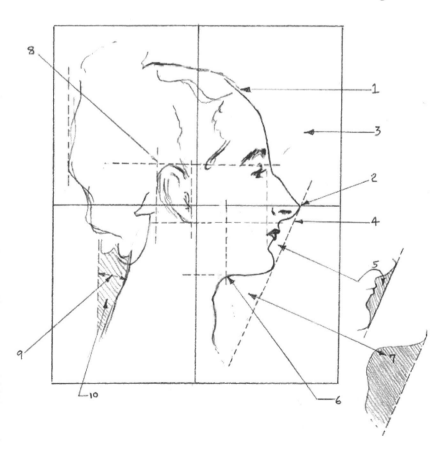

Post-exercise remarks:

If you lay one finger over the features in the Sargent drawing, you will see what a small proportion of the whole form is occupied by the features of the face. It is often quite surprising when you first really see the proportions of the human head.

This exercise has provided practice in flexibly moving through the first three skills of drawing: edges, spaces, and relationships. As you will find with further practice, these strategies of seeing are somewhat interchangeable. If you are having trouble drawing an edge, the adjacent negative space will solve the problem. If you are having trouble assessing an angle, envision the angle as a negative space bounded by an imaginary vertical or horizontal edge. This redundancy of strategies helps to make drawing easy and enjoyable.

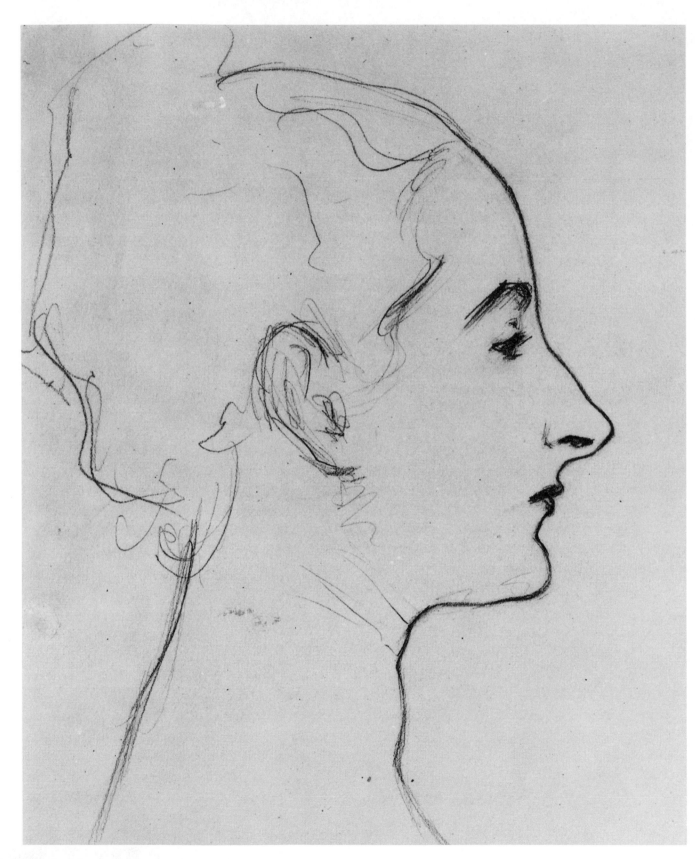

John Singer Sargent. *Madame X.* **Graphite on off-white paper. The Metropolitan Museum of Art, Gift of Frances Ormond and Miss Emily Sargent, 1931. (31.43.3).**

EXERCISE 27 COPYING A MASTER DRAWING OF A PROFILE PORTRAIT

EXERCISE 28

Drawing a Profile Portrait

Materials:

#2 and #4B pencils, sharpener, and eraser

Picture Plane/Viewfinder

Felt-tip marker

Graphite stick and paper towel for setting the ground

Note: For this exercise, you will need a model willing to pose for 30 to 60 minutes (with breaks, of course; the model can be reading or watching television).

Time needed:

About 1 hour

Purpose of the exercise:

Now that you have learned the proportions of the head in profile by copying the two-dimensional image of the John Singer Sargent drawing, the next step is to draw a profile from life, using a model. Drawing from life is always more challenging and therefore more satisfying.

Instructions:

1. Turn to page 102 of the workbook, with the printed format.

2. Set a ground and then lightly draw in the crosshairs.

3. Seat your model in profile view, and seat yourself fairly close to the model. (Four or five feet away is a good distance.) See Figure 28-1.

4. Using the Picture Plane/Viewfinder, compose your drawing so that the model's head is framed within the edges of the Viewfinder.

5. Choose a Basic Unit: I suggest eye level to chin for this drawing. Mark the Basic Unit on your Picture Plane/Viewfinder with your felt-tip marker. Two marks, one at the model's eye level and one at the bottom of the chin, are enough to establish your Basic Unit. You may wish to draw the outline of the head, but be aware the line will be shaky. See Figures 28-2 and 28-3.

6. Next, transfer the two marks defining the Basic Unit to your format. See Figure 28-4.

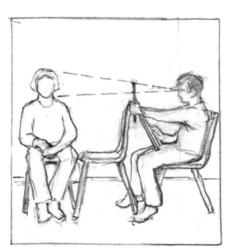

Figure 28-1.

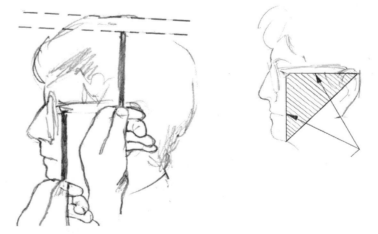

Be sure to check the proportions you learned in Exercise 26.

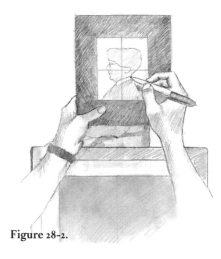

Figure 28-2.

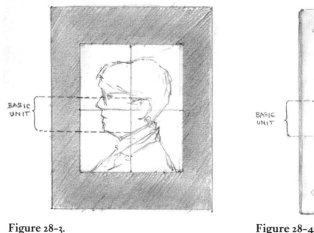

Figure 28-3.

Figure 28-4.

7. Start with the features in profile by drawing the *negative space* in front of the forehead, nose, lips, and chin. See Figures 28-5 and 28-6.

8. Now, follow steps 4 through 15 in Exercise 26.

9. If you wish, erase the ground around the head. This helps greatly in seeing the large form of the head and the relationship of the features to the whole head.

10. In drawing the model's hair, squint your eyes to see the larger highlights and the shadows. *Avoid drawing symbolic hair—repeated parallel or curly lines.* Hair forms a shape. Focus on drawing that shape.

11. Be sure to include the model's neck and shoulders, which provide a support for the head, and include some indication of the model's clothing.

12. When your drawing is finished, erase the crosshairs if you wish. Sign and date the drawing, adding the model's name.

Post-exercise remarks:

Ideally, you would have two or three sittings with your model, and during each sitting you would make tiny adjustments to the edges, spaces, and relationships. Sometimes, changing a line by just the width of a pencil line will be the move that suddenly captures the likeness. Be alert for these moments: they are truly satisfying.

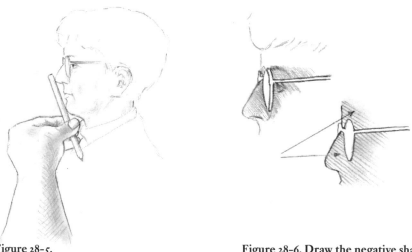

Figure 28-5.

Figure 28-6. **Draw the negative shapes around eyeglasses.**

EXERCISE 28 DRAWING A PROFILE PORTRAIT

101

EXERCISE 28 DRAWING A PROFILE PORTRAIT

EXERCISE 29
Still Life with American Flag

Materials:

Charcoal and paper towel, for setting a ground

Charcoal pencil and eraser

Picture Plane/Viewfinder

Felt-tip marker

An American flag of any size
(or, if a flag is not available, a striped towel or shirt)

Time needed:

30 to 40 minutes

Purpose of the exercise:

So far, you have been focused on the first three component skills of drawing: edges, spaces, and relationships. This exercise is a return to still-life drawing, emphasizing the same three skills but using a different subject—the American flag.

The flag is useful as a subject because we know it so well. We have an embedded knowledge that the flag's stripes are straight and all the same width, and that the stars are all the same shape. Because we "know" this, when we try to draw the flag it can be difficult for us to accept the perception of crossed stripes that occurs whenever the flag is folded on itself. Equally difficult to accept are perceptions that the stripe widths appear to change due to ripples in the fabric, and that the stars can appear to be varied in their shapes depending on how the fabric is folded. For this reason, the flag is a good subject for practicing drawing exactly what you see on the plane, without second-guessing the visual data.

Instructions:

1. Turn to page 105 in the workbook, with the printed format.

2. Tone your paper to a pale ground with your charcoal, rubbing with a paper towel to a smooth tone. Lightly draw the crosshairs with your charcoal pencil.

3. Arrange an American flag on a table, hanging at an angle from a flagpole, or draped over a chair, so that the stripes appear to cross.

A student's pre-instruction drawing of a flag. A post-instruction drawing of a flag.

4. Using the Picture Plane/Viewfinder, compose your drawing. Choose a Basic Unit—perhaps the width of the field of stars—and draw it with your felt-tip marker on the plastic plane.

5. Transfer your Basic Unit to your toned paper. With your charcoal pencil, start your drawing by completing the edges of the field of stars.

6. Use your pencil to sight the angles of the stripes as they appear on the plane. Angles are always assessed relative to vertical and horizontal on the plane. If you are not sure of your sights, hold up the Picture Plane and check them relative to the vertical and horizontal edges of the plane and the crosshairs. Draw the angles just as they appear on the plane.

7. If your flag has ripples in the fabric, close one eye and observe that the widths of the stripes appear to change (see the accompanying drawing). Draw these width changes just as you see them.

8. Note that the stars in the flag will appear to change shape because of the effects of perspective on them. They may not always be symmetrical; they may appear to be quite distorted in shape. Draw the stars just as they appear on the plane.

9. Sign and date your finished drawing.

Post-exercise remarks:

Often, the seemingly simplest subjects provide the best lessons in drawing. This is true of the flag. This drawing may seem difficult at first, but once you accept what you see on the plane, it becomes easy. Learning that is an important lesson. Drawing should be easy, and it is easy, once we stop fighting our stored conceptual knowledge about how things "should be" and simply accept perceptions as they appear on the plane.

The next exercises will focus on the fourth skill: seeing lights and shadows. After the rigors of sighting, joy returns to drawing, because lights and shadows are powerful elements in depicting the three-dimensionality of forms—or in "making things look real," as my students sometimes put it.

Drawing by the author.

EXERCISE 30

Drawing an Egg Lighted from Above

Materials:

Charcoal and paper towel, for toning a ground

Charcoal pencil and eraser

Picture Plane/Viewfinder

Felt-tip marker

White-shelled egg or eggs, in an egg carton

Piece of white paper, 9" x 12"

Lamp or spotlight

Time needed:

About 25 minutes

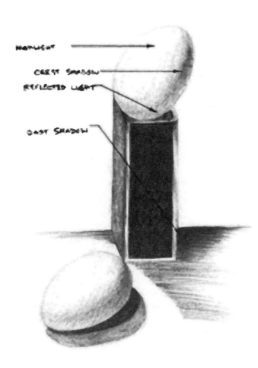

Figure 30-1. Drawing by student Elizabeth Arnold.

Purpose of the exercise:

This exercise introduces the fourth skill, the perception of lights and shadows, and builds on the first three skills (edges, spaces, and relationships). You will see the edges of the shapes of lights and shadows as either negative shapes or positive forms, and you will see the shapes of lights and shadows in relationship to each other and to the whole of the drawing.

Lights and shadows are usually not perceived at a conscious level in ordinary life. We see lights and shadows subconsciously; they tell us the shapes of things, but we are generally not aware of this mental process. In drawing, however, we need to see lights and shadows at a conscious level. They are very beautiful, and seeing and drawing them is extraordinarily satisfying. See Figure 30-1.

In traditional art instruction, there are four aspects of light and shadow. Together, these are called the logic of light, or, in short, light logic. These aspects are: highlight, cast shadow, reflected light, and crest shadow. See Figures 30-1, 30-2, and 30-3.

Highlights are the lightest lights in a picture.
Cast shadows are the darkest darks in a picture.
Reflected lights are not as light as highlights.
Crest shadows are not as dark as cast shadows.

Note: The lightest light you can achieve is the white of the paper. The darkest dark you can achieve is the darkest mark your pencil or charcoal will make.

In this exercise, you will be drawing an egg or, if you prefer, several eggs. Because the use of light logic applies especially to rounded forms, an egg lighted from above effectively demonstrates the four characteristics of lights and shadows.

Instructions:

1. Turn to page 108 of the workbook, with the printed format. Look at the accompanying drawing of an egg, pointing out the four areas—highlight, cast shadow, reflected light, and crest shadow. Light rays, bouncing off the flat surface the egg sits on and softly lighting the underside of the egg, create areas of reflected light. Light rays bypassing the egg result in crest shadows on the outermost crest of the egg's curved form.

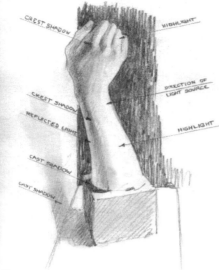

Figure 30-2.

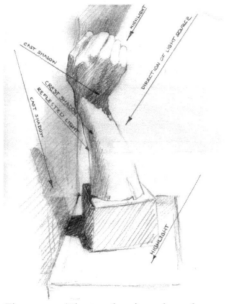

Figure 30-3. The two drawings above demonstrate how lights and shadows change when the light source is moved. Where is the light coming from in Figure 30-2? In Figure 30-3? In Figure 30-4?

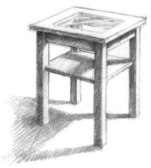

Figure 30-4.

2. Using your charcoal, tone the paper within the format to a pale gray. Rub it to a smooth tone. Lightly draw crosshairs in the format using your charcoal pencil.

3. Arrange a still life with an egg or several eggs on a piece of white paper. Use the lamp or spotlight to illuminate the still life from above and slightly to one side in order to produce cast shadows, meaning the shadows produced when objects block light rays.

4. Using the Picture Plane/Viewfinder, choose your composition and then choose a Basic Unit; I suggest the width or length of one egg.

5. Use your charcoal pencil to transfer your Basic Unit to the format.

6. Now draw the main edges, spaces, and relationships of the eggs and the shadows they cast. The negative spaces around the eggs and cast shadows will help you to see the shapes accurately.

7. Squint your eyes and search the still life for the *lightest* lights and the *darkest* darks. Erase the highlights on the eggs and darken the cast shadows with your charcoal pencil.

8. Carefully observe the crest shadows and the reflected lights on the eggs. See Figure 30-1. Using your eraser and charcoal pencil, slightly lighten the reflected lights and slightly darken the crest shadows to approximate the values you see in those areas of the eggs.

9. Carefully erase the crosshairs; sign and date your drawing.

Post-exercise remarks:

More than anything, I believe, students want to know how to "shade" their drawings so that forms look three-dimensional. The ability to see subtle differences in values (the lightness or darkness of one area compared to another) is one of the key requirements for achieving this goal. The four aspects of light that you have learned in this lesson will help you to see those differences by knowing what to look for and then bringing them to your conscious awareness. Once you can see the four aspects of light, you can draw them.

EXERCISE 30 DRAWING AN EGG LIGHTED FROM ABOVE

EXERCISE 31

Charlie Chaplin in Light and Shadow

Materials:

Charcoal, natural or synthetic

Charcoal pencil and eraser

Picture Plane/Viewfinder

Time needed:

30 to 40 minutes

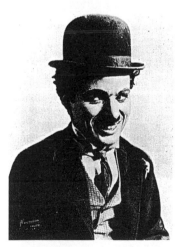

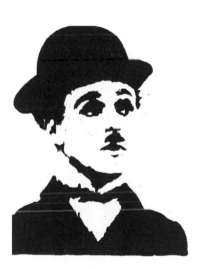

Charlie Chaplin. Photograph by Hartsook.
International Portrait Gallery.

Purpose of the exercise:

In the exercises on edges, spaces, and relationships, you were encouraged to see and draw fine details in order to increase your ability to discriminate slight changes in edges, shapes, angles, and proportions. With the fourth skill, the perception of lights and shadows, the focus shifts somewhat.

The visual system of the human brain can visualize—that is, see in the mind's eye—missing information from incomplete cues. In drawing, this means that if you give your viewer just enough clues about the subject of a drawing, the viewer can *envision* the missing parts, and viewers of drawings seem to greatly enjoy the envisioning process. The photograph of Charlie Chaplin you will be copying in this exercise is a good example of allowing shadows to obscure details, thus requiring the viewer to fill in the missing parts.

Note: Because of the harsh light used in the Hartsook photo of Chaplin, reflected lights and crest shadows (which you drew in the previous exercise) are obscured.

Instructions:

1. Turn to page III of the workbook, with the printed format.

2. Tone your format to a fairly dark shade with charcoal, rubbing to smooth the tone. The natural charcoal is soft and easy to use for setting a ground, but it smears easily. Synthetic charcoal makes a darker tone and is less subject to smearing, but it does not erase as easily as the natural charcoal. Try both on some scratch paper and choose the one you like best.

3. Using your charcoal pencil, lightly draw crosshairs both within your format and on the reproduction of the Chaplin photo.

4. Choose a Basic Unit and transfer it to your drawing using the charcoal pencil. The width of the crown of the hat would make a good Basic Unit.

5. Using the crosshairs and your Basic Unit to guide you, copy the main edges of the portrait, paying close attention to the shapes of the negative spaces around the figure as well as the interior negative shapes.

6. With your eraser, begin to erase out the lighted shapes, leaving the shadow shapes in the dark tone of the ground. It may help to turn the drawing upside down for part of your drawing time.

7. Notice how little detail is required in the features. Draw only what you see. Chaplin's right eye, for example, is almost entirely portrayed by the large dark shape around the eye and the tiny shape of the white of the eye.

8. Regard lines as narrow shadow shapes: see the edges of the vest and the shadows around the mouth.

9. Use your charcoal pencil to finish the drawing, but be careful not to over-draw the image. Do not add what is not there.

10. When you are finished, erase the crosshairs. Sign and date your drawing, adding, "Charlie Chaplin, after a photo by Hartsook."

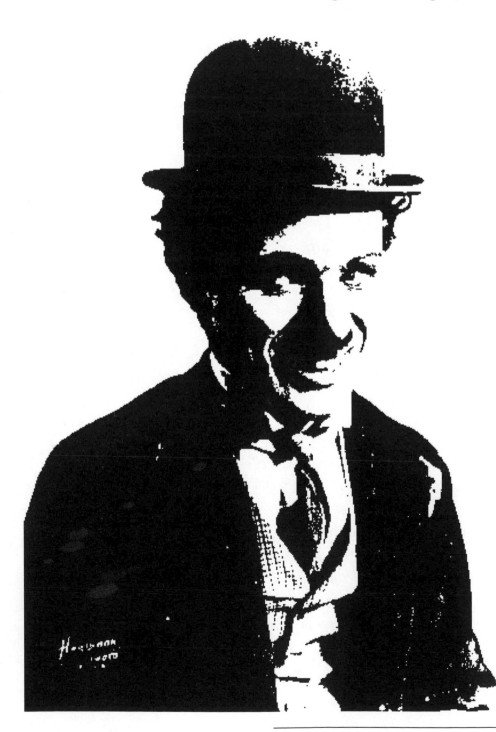

Post-exercise remarks:

In light/shadow drawing, the lighted shapes and the shadowed shapes can be thought of as positive and negative spaces: if you draw (or erase) one, you have simultaneously drawn the other. If there seems to be an error somewhere in your drawing, compare first the lighted shapes and then the shadowed shapes in your drawing of Chaplin with those in the original photograph. If one or the other does not match the shapes you see in the photograph, make the necessary adjustments.

One of the secrets to successful light/shadow drawing is to allow your viewer to envision what is left out. As mentioned, this gives the viewer great pleasure, and the viewer is grateful for being allowed to "see into" the drawing. Don't give away the game by adding too much detail.

EXERCISE 32

Proportions of the Head in Full-Face View

Materials:

#2 and #4B pencils, sharpener, and eraser

Time needed:

About 15 minutes

Purpose of the exercise:

In Exercise 26, you learned to draw the proportions of the head in profile. The next challenge is to draw a portrait in full-face view, incorporating the fourth skill, the perception of lights and shadows. This exercise in learning the general proportions of the human head in full-face view is helpful in portrait drawing, because these proportions seem to be difficult to see without training. The most frequent error is enlarging the features relative to the whole shape of the head. It is well worth taking the time to memorize and then practice seeing the correct proportions in order to avoid persistent errors in drawing faces.

Instructions:

1. Turn to pages 114 and 115 in the workbook, which show the full-face diagram and the blank diagram side by side.

2. Working carefully and memorizing as you go, draw in the proportions of the features in the blank diagram. Go back over the diagrams at least once to help you remember the main points, especially these:

 a. Eye level to chin equals eye level to the top of the head. (Note that the thickness of the hair is added to the upper proportion.)

 b. The space between the eyes equals the width of one eye.

3. Check these proportions on your own face by looking in a mirror. Use your pencil to measure the key proportions. If possible, find someone who is willing to be a measurement model for you and check the proportions again, measuring directly on the model's head with your pencil. You can also use full-face photographs as measurement models.

Pre-instruction drawing by Howard Rhodes, September 1, 1984.

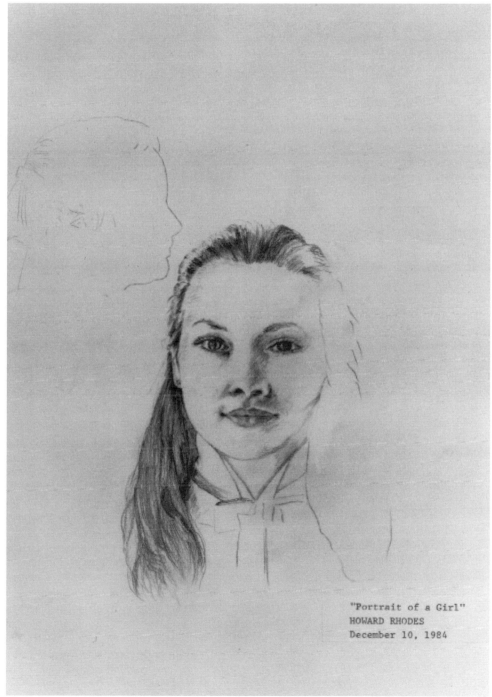

"Portrait of a Girl"
HOWARD RHODES
December 10, 1984

Post-instruction drawing by Howard Rhodes, December 10, 1984.

FULL VIEW
GENERAL PROPORTIONS OF THE HUMAN HEAD - USE AS A GUIDE TO PROPORTIONS

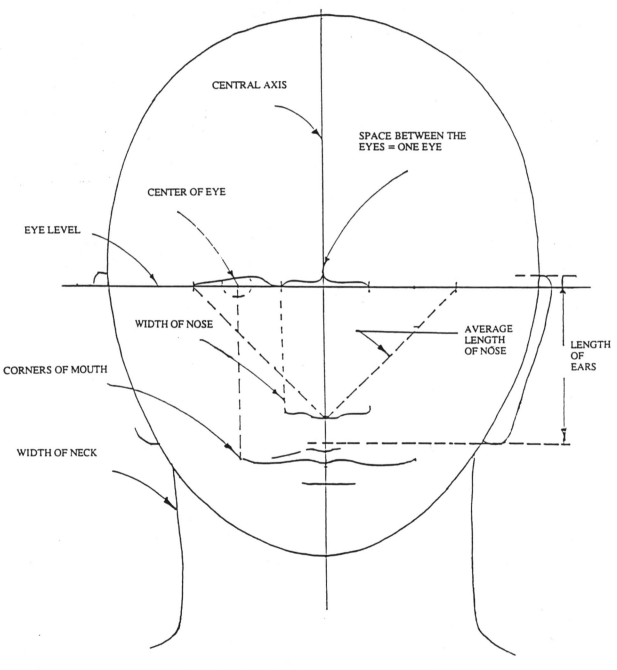

CENTRAL AXIS

SPACE BETWEEN THE
EYES = ONE EYE

CENTER OF EYE

EYE LEVEL

WIDTH OF NOSE

AVERAGE
LENGTH
OF NOSE

LENGTH
OF
EARS

CORNERS OF MOUTH

WIDTH OF NECK

EYE TO THE CHIN = EYE TO THE TOP OF THE SKULL

EXERCISE 33

Copying a Full-Face Portrait

Materials:

Charcoal and paper towel, for toning a ground

Charcoal pencil and eraser

Picture Plane/Viewfinder

Time needed:

About 30 minutes

Purpose of the exercise:

In this exercise, you will be using charcoal to copy a full-face self-portrait by Picasso, also drawn in charcoal. You will gain practice not only in drawing the proportions of the head, but also in using charcoal to create a range of dark and light values.

Portrait drawing requires precise discriminations in terms of edges, spaces, relationships, and lights and shadows. Before you start your drawing, compare the generalized proportions of the head as shown in the Exercise 32 diagram with the proportions of Picasso's head. You will find minute variations. For example, Picasso drew his left eye slightly lower than his right eye. The mouth is slightly wider on the right side of his face than on the left. His right ear is slightly higher than his left ear. By making these very fine visual discriminations and drawing your perceptions just as you see them, you will capture Picasso's likeness.

Instructions:

1. Turn to page 118 in the workbook, the reproduction of Picasso's *Self-Portrait*, Barcelona, 1899–1900. On page 119 is a format with approximately the same proportions as the original.

2. Tone your paper lightly with charcoal, rubbing it to a smooth tone with the paper towel. Lightly draw crosshairs with charcoal pencil and, if you wish, draw crosshairs on the reproduction drawing. If you prefer, you can lay your Picture Plane/Viewfinder directly on top of the reproduction to provide the crosshairs.

3. Choose a Basic Unit: eye level to chin, the length of the nose, the distance from the outside corner of one eye to the outside corner of the other eye, or any Basic Unit you prefer. Transfer your Basic Unit to your toned ground, using the crosshairs to guide the placement.

4. Using the crosshairs to guide you, begin to draw the head on your toned paper with your charcoal pencil. You may start with the features or the large shape of the head.

5. Check all the proportions as you draw. You will find that though they closely conform to the full-face diagram proportions, there are slight differences. Pay close attention to those differences and draw them just as you see them.

6. Use the shapes of the negative spaces around the head—for example, the dark shape on the left side of the reproduction, which will define for you the shape of the jaw, ear, and hair. Use your charcoal stick to darken in those negative spaces.

7. Try using the whites of the eyes as interior negative shapes, rather than drawing the irises of the eyes. This will help you to place the irises correctly.

8. Once you have sketched in the main features, begin erasing out lighted areas and darkening shadowed areas. Squint your eyes to see the lightest lights (the highlights) on the nose, the temple, and the shirt. Draw the cast shadows beside the nose, under the brow, the cheekbone, the upper lip, and the chin. Softly erase the reflected light on the right jaw and darken the crest shadows on the right cheekbone and jaw. Be sure not to add more detail than you see in the drawing.

9. When your drawing is finished, carefully erase the crosshairs. Sign and date the drawing, noting that it is "After Picasso." Since charcoal drawings smear easily, you may want to spray your drawing with charcoal fixative, but be aware that the fixative will slightly change the appearance of the charcoal.

Post-exercise remarks:

This exercise has provided practice in four of the basic perceptual skills—seeing and drawing edges, spaces, relationships, and lights and shadows—as well as practice in seeing and drawing the head in correct proportion and in using charcoal as a drawing medium.

The Charlie Chaplin drawing was in two values only: black and white. The Picasso drawing has a wider range of values—very light, light, medium, and dark—and therefore has given you an opportunity to see and draw the four aspects of light logic: highlights, cast shadows, reflected lights, and crest shadows. All of this is helpful preparation for the next challenge, drawing your self-portrait.

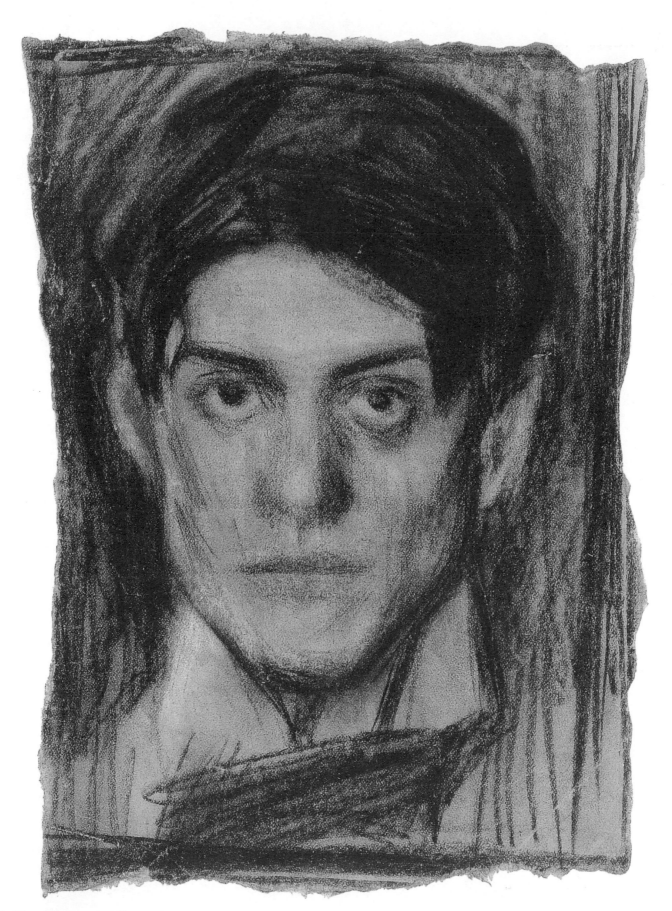

Pablo Picasso (1881–1973), *Self-Portrait*, Barcelona,
1899–1900. Charcoal on paper, 22.5 x 16.5 cm.
Picasso Museum, Barcelona. ©2002 Estate of Pablo
Picasso/Artist Rights Society (ARS), New York.

EXERCISE 34

Drawing Your Self-Portrait in Light and Shadow

Materials:

Mirror

#2 and #4B pencils, sharpener, eraser

Felt-tip marker

Dampened tissue for corrections

Graphite stick and paper towel, for setting a ground

Note: You will need a floor lamp or clip-on light to illuminate one side of your head.

Time needed:

1 to 2 hours

Purpose of the exercise:

Self-portraits are often described as one of the most difficult tasks in drawing, but they are actually neither different from nor more difficult than other kinds of drawing. All drawings require the same basic component skills that you have been studying: seeing edges, spaces, relationships, and lights and shadows. I believe the real problem is that each of us has a strongly embedded, memorized set of symbols for the human face, developed during childhood. Setting this symbol system aside is the difficult part. Moreover, we have beliefs about our own appearance (both positive and negative), as well as memories of how we appeared in the past, and these can affect our perceptions.

As always, the solution is to draw just what you see, always checking relationships against one another. A reminder: in drawing your self-portrait, remember to include seeing and drawing negative spaces in order to strengthen your composition and the unity of spaces and shapes.

Remember, drawing is not photography. Self-portraits drawn by the same artist vary greatly one from another as shown in these drawings by instructor Brian Bomeisler. While still portraying a likeness, the setting and mood change.

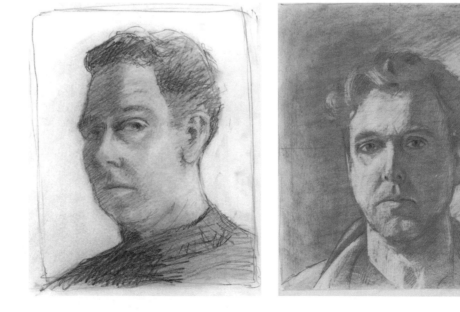

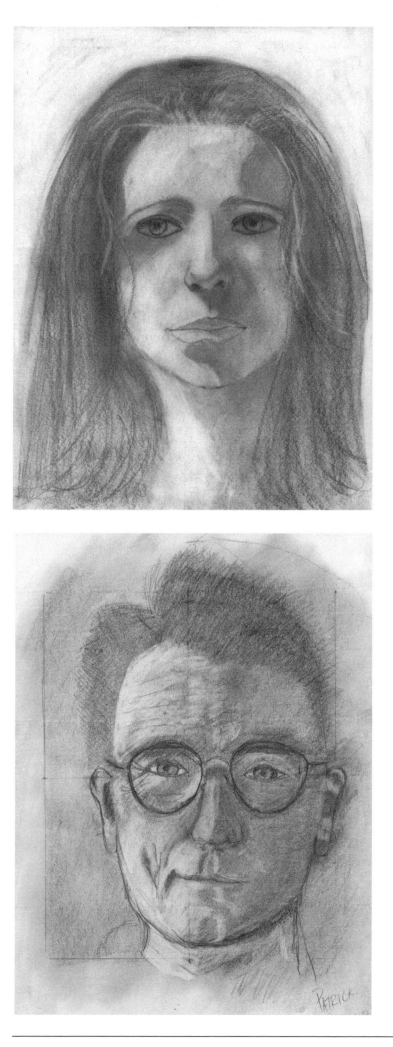

Above: Self-portrait before instruction, by Rebecca Feldman, age 14, June 21, 1999.
Right: Self-portrait after instruction, June 25, 1999.

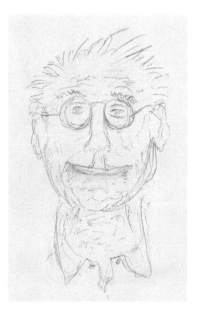

Above: Self-portrait before instruction, by Patrick O'Donnell, June 21, 1999.
Right: Self-portrait after instruction, June 25, 1999.

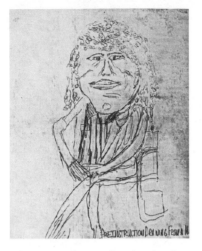

Above: Pre-instruction drawing by
Tony Schwartz, July 12, 1989.
Right: Self-portrait after instruction,
July 16, 1989.

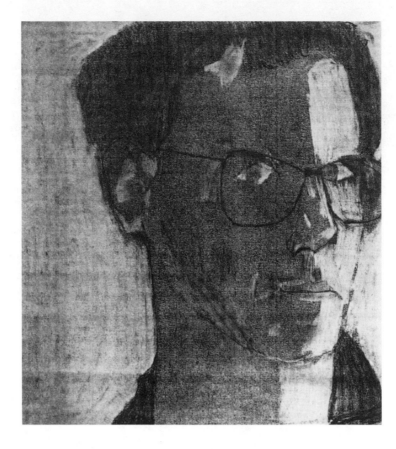

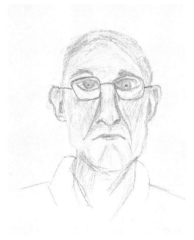

Before and after self-portraits
by a student in a five-day workshop.

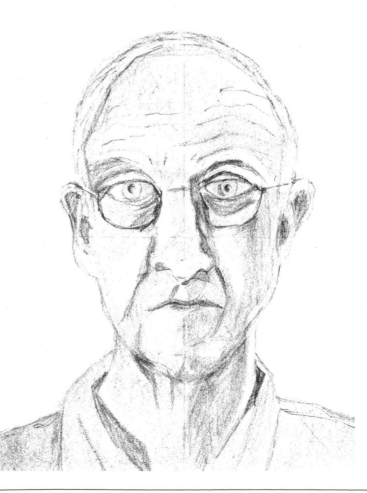

Figure 34-1.

Figure 34-2.

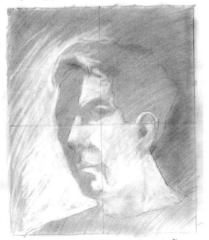

Figure 34-3.

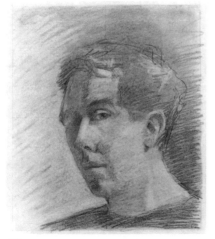

Figure 34-4.

Instructions:

1. Turn to page 125 of the workbook, with the printed format. Using graphite and a paper towel, set a ground with a medium-dark tone. Lightly draw a set of crosshairs within the format with your #2 pencil.

2. Sit in front of the mirror. Reach forward, and with the felt-tip marker and a ruler, draw a format edge on the mirror, about 6" x 8½". Now, draw crosshairs on the mirror within the format. When you are drawing a self-portrait, the mirror becomes the picture plane. The mirror flattens your image. See Figure 34-1.

3. Gaze at your reflection in the mirror, trying various positions of your head to compose the drawing. Choose a Basic Unit—perhaps two marks that designate eye level and the bottom of your chin. See Figure 34-2.

4. Using your #2 pencil, transfer the marks of your Basic Unit to your format. This will ensure that the drawing of your head will be correctly sized within the format, neither too large nor too small. Then, lightly sketch in the main edges and spaces of your head and face. It is not necessary to draw in every detail of your features: sometimes the parts you leave for the viewer to envision turn out to be the best parts of a drawing.

5. Now, look for the shapes of lights and shadows in your image. Work mainly with the eraser to start, erasing out the large lighted shapes. For example, you might erase out the negative spaces around your head; alternatively, you might darken the negative spaces, as Picasso did in his self-portrait. Establishing the shape of the head helps you to envision the features.

6. Squint your eyes and look at your image in the mirror to find the lightest lights, the highlights, and the darkest darks (which are often the cast shadows). Erase the highlights and darken the cast shadows with your #4B pencil. See Figure 34-3.

7. Squint your eyes again to find any areas of reflected light—for example, light reflected under the jaw or chin from a light-colored shirt or blouse. Softly erase the areas of reflected light.

8. Squint your eyes again to find any areas of crest shadows, often found on the nose, the cheekbone, the jaw, or the chin. Carefully darken the crest shadows.

9. Use the whites of your eyes as interior negative spaces to correctly locate your irises. You will probably find that the whites of your eyes are not as light as highlights. Carefully erase the whites and darken the irises, comparing these tones to your lightest and darkest values before drawing them.

10. Find and erase any highlights you see on your hair. This will help to establish the character and shape of the hair.

11. In continuing to draw the features, leave some details for the viewer to envision, especially in the shadowed areas. See Figure 34-4.

12. When the drawing is finished, sign and date it.

Post-exercise remarks:

You will find it interesting to compare this drawing to the pre-instruction self-portrait you drew in Exercise 1. I feel sure that you will be pleased at the comparison. In the past, I have had students who literally did not recognize their pre-instruction self-portraits as their own work, because their skills had advanced so much farther.

As you compare the two drawings, think about what you have learned since the first drawing, and how that learning is evidenced in your new self-portrait. Often, students find that the first drawing includes memorized symbols from childhood, which are often particularly evident in the eyes, the nose, and the ears, as well as in the enlargement of the features relative to the full head. It might be interesting for you to measure the relationship "Eye level to chin equals eye level to the top of the head" in both of your self-portraits.

A second characteristic I have often seen in the pre-instruction self-portraits is a kind of blandness or blankness in expression. In contrast, the post-instruction self-portraits are often intense—sometimes very intense and serious—and always full of life.

In judging your drawing and hoping for an exact likeness, be aware that *self-portrait drawing is not photography.* The next self-portrait you draw may show another aspect of your appearance, and the next yet another. If you look at a series of self-portraits by the same artist—for example, Rembrandt or Van Gogh—they look remarkably different from one another. In each self-portrait, you recognize the person, but you see an image painted or drawn with a different mood and from a different point of view.

**Part V
The Perception
of the Gestalt**

Ellsworth Kelly (1923– ; American). *Apples*, 1949. Pencil, 17⅛ x 22⅛ inches. Museum of Modern Art, New York (gift of John S. Newberry, by exchange).

Shokei (1628–1717), *Mist Rising*. Signed "Hokkyo Shokei, aged 86." Kanō School. Landscape in ink on paper, 290 x 530 mm. Bigelow Collection, Museum of Fine Arts, Boston.

A Definition and Explanation of "The Perception of the Gestalt"

The word gestalt literally means "shape," but it has evolved to signify a set of elements, thoughts, or perceptions that, when taken all together, amount to more than the sum of the parts. The perception of the gestalt is the fifth component skill in drawing. The image is seen to be more than the sum of the materials from which it is made, the subject it portrays, and the other component perceptions of edges, spaces, relationships, and lights and shadows. The image, taken all together, has a meaning and a purpose of its own: to portray the inherent character of the subject, whether the drawing is a self-portrait or a depiction of a single flower, an egg, or one's own hand. In the language of Zen, the ancient Buddhist philosophy, the gestalt represents the "thingness of the thing," its essential nature.

In this workbook, I have taught you the first four drawing skills— edges, spaces, relationships, and light/shadow—by direct, specific instructions. The fifth skill, however, the perception of the gestalt, cannot be taught directly. I can name, describe, and point it out to you, but it is an experience that will need to simply happen as a result of your slowing down and perceiving something with the focused attention required for drawing. I feel sure that you have experienced the gestalt already, perhaps when you drew the flower and suddenly perceived how extraordinarily complicated and beautiful the flower seemed, or when you drew the profile portrait and were surprised at how suddenly beautiful the person you drew seemed.

I believe the perception of the gestalt can be equated with the "aesthetic response," which is a term from the branch of philosophy called aesthetics, the study of beauty. The aesthetic response occurs at that moment when you suddenly see the beauty of something, whether an idea, an elegant solution to a problem, or something familiar seen in a new way. The perception of the gestalt is one of the great pleasures of drawing. An artist who has experienced it once hopes to have the experience again. The perception of the gestalt can thus keep you drawing forever.

In this section of the workbook, I will present a variety of new exercises, subjects for drawing, media, and techniques. I hope that you will experience the aesthetic response, the perception of the gestalt, in every drawing you do from this point forward.

EXERCISE 35

Using Ink and Brush

Materials:

Drawing ink, such as India ink
or brown ink made for writing pens

#2 pencil, sharpener, and eraser

#7 or #8 watercolor brush

Saucer or plate for mixing the ink
with water

Jar of water and some paper towels
or clean rags

Time needed:

About 20 minutes

Purpose of the exercise:

Instead of charcoal or pencil, in this exercise, I'd like you to try using ink and brush. This medium is a bit daunting at first, because you cannot erase to correct mistakes. In this drawing, however, you will lightly sketch the image first and then add water-thinned ink with a brush. This is a useful technique for making quick sketches.

In this exercise, you will be copying an ink-and-brush self-portrait by Picasso. I have chosen this drawing not only because it beautifully demonstrates ink and brush technique, but also because it reinforces the lesson you learned with the fourth skill, lights and shadows, that a surprising amount of detail can be left for the viewer to envision.

Instructions:

1. Turn to page 129 of the workbook, with an approximately square format for use with *Self-Portrait*, Barcelona, 1900 by Picasso, on page 128.

2. You may want to turn the drawing upside down to better see the large shadow shape on Picasso's head and face. That shape defines the features. Then, turn the drawing right side up and sketch the main edges and negative spaces directly onto the paper. For this drawing, imagine the crosshairs and choose a Basic Unit without literally going through all the steps of the process.

3. Mark your Basic Unit within the format. Begin to draw the edges of the large shapes of lights and shadows, sizing them in proportion to your Basic Unit. *Do not add more detail than you see in the original.* For example, half of the lower lip is left undefined. Draw the shapes of the shadows in that area just as you see them.

4. Make sure your eye-level proportion is correct. Remember, eye level to chin equals eye level to the top of the head. Because the hair is thick, you must add a bit more to the upper proportion.

5. Once your sketch is complete, dip your brush in ink, then in water to thin the ink, and begin to paint the outlines of the head, the shoulder, and shirt. Notice that the brush continues around the edge of the format to frame the head.

**Brush and ink drawing by student Brenda
Sanders.**

6. Dip the brush in ink again and paint the large shadow shape, which shapes the eyebrow, nose, mouth, and chin.

7. Carefully make the small shadow shapes on the lighted side of the head that complete the features.

8. When your drawing is finished, sign and date it, adding "After Picasso."

Post-exercise remarks:

This drawing will surely illustrate for you the power of light/shadow drawing. Can't you envision the eye, nose, and mouth in the shadowed side of Picasso's head, even though there is nothing there but a featureless shadow? Envisioning the missing features will help to trigger the perception of the gestalt.

Pablo Picasso (1881–1973) *Self-Portrait,* **Barcelona, 1900. Pen, ink, and watercolor on paper, 9.5 x 8.6 cm. The Metropolitan Museum of Art. Raymond Paul donation, in memory of his brother, C. Michael Paul, 1982. ©2002 Estate of Pablo Picasso/Artist Rights Society (ARS), New York.**

EXERCISE 36
An Urban Landscape
Drawing

Materials:

#2 pencil

Free-flowing, fine-tipped, black-ink
writing pen, such as the Sanford
Uniball Micro pen

Picture Plane/Viewfinder

Felt-tip marker

Time needed:

30 to 45 minutes

Purpose of the exercise:

Since few of us have an easily accessible rural landscape available, in
this exercise you will be drawing a scene more familiar to many of us,
an urban landscape. This may seem an unlikely subject for a drawing
because such scenes are so familiar we barely take notice of them. The
purpose of this exercise is to demonstrate that *any scene and any subject*,
when lovingly viewed and carefully drawn, can be the subject of
a beautiful drawing. In this drawing, you will concentrate on edges,
negative spaces, relationships, and perceiving the gestalt of a perhaps
unlikely subject.

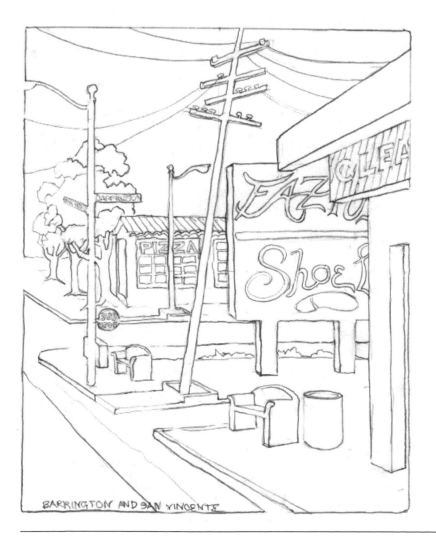

Instructions:

1. Turn to page 132, with the printed format.

2. By automobile or on foot, explore your neighborhood or town to locate what you might describe as a truly ugly corner, full of signboards, stoplights, and storefronts.

3. Park your car (or set up a folding chair if you are on foot) near the truly ugly corner, and prepare to draw while sitting in your car or on your folding chair.

4. Use your Picture Plane/Viewfinder to frame the view. Choose a composition.

5. Choose a Basic Unit. Draw it on the plastic plane with the felt-tip marker.

6. Transfer the Basic Unit to the paper using your #2 pencil.

7. Sketch the main edges. You may use pencil, or you may start drawing directly with the pen if you wish.

8. Using line only, begin to draw the scene bounded by your Viewfinder, at first focusing mainly on the negative spaces. If you have signboards in your scene, draw the letters by drawing the negative spaces around the letters. This will unify the letterforms into the composition (if you drew the letters themselves, they would "pop out" of the composition).

9. Work from spaces to adjacent shapes, and from shapes to adjacent spaces. Use your pencil to sight angles relative to vertical and horizontal, and proportions relative to your Basic Unit. Fit the parts together as though the scene were a complex, fascinating puzzle.

10. When you have finished drawing all the edges of the shapes and spaces, you may want to use your pen or pencil to darken in some of the shapes or spaces. Alternatively, you may wish to keep the drawing as a pure line drawing.

11. When you have finished, sign and date your drawing. You may wish to add a title—*Urban Landscape, An Ugly Corner, Fifth and Broadway.*

Post-exercise remarks:

In this drawing, your subject—the urban landscape—was probably made up of mostly straight lines and angles, but the same drawing technique can be readily applied to other kinds of landscapes as well. Negative spaces, for example, are enormously helpful in drawing tree trunks, branches, and the spaces around clumps of leaves.

I hope this drawing convinces you that subject matter is of very little importance in drawing. Anything—an old pair of shoes, a baseball cap, a towel hung over the back of a chair, an unmade bed—can, when lovingly observed, produce a beautiful drawing and provide a sense of the gestalt.

EXERCISE 36 AN URBAN LANDSCAPE DRAWING

EXERCISE *37*

Hatching and Crosshatching

Materials:

#2 and #4B pencils, sharpener, and eraser

Pen and ink, or a writing pen with a medium-fine tip

Charcoal and a charcoal pencil

Conte crayon, black or sanguine (reddish brown)

Time needed:

About 20 minutes

Purpose of the exercise:

Hatching and crosshatching are techniques of shading with rapid parallel lines that often intersect or cross. Almost every trained artist uses hatching or crosshatching to give the effect of shadow or texture change. In addition, crosshatching allows a lovely sense of light and air to permeate a drawing. Each artist over time develops a personal style of hatching or crosshatching, just as you will in time develop your own way of crosshatching. In the early stages of learning to draw, crosshatching seems to require some instruction, as indicated in the reproduction of a page from a 1930s book on drawing.

Instructions:

1. Turn to page 135 of the workbook, printed with six small formats.

2. Within each of the formats, practice making hatches and crosshatches as in the examples given in the early drawing manual:

 a. In Format 1, use your #2 writing pencil.

 b. In Format 2, use your #4 drawing pencil.

 c. In Format 3, use pen and ink or a writing pen.

 d. In Format 4, use charcoal or charcoal pencil, or both.

 e. In Format 5, use conte crayon.

 f. In Format 6, use your favorite style of hatching, using any of the above mediums.

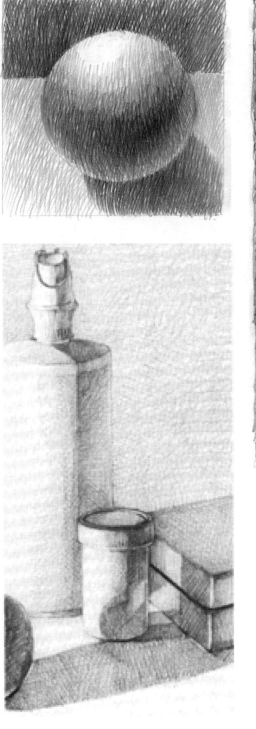

·2· THE SHARP POINT·

·A· EVEN PRESSURE·

·B· GRADED PRESSURE·

·C· ACCENTED ENDS·

·D· FADED ENDS·

·E· WAVY · BROKEN·

·F· QUICKLY DRAWN·

·G· CROSSHATCH·

Post-exercise remarks:

It is through practice that your own style of hatching or crosshatching will develop. I suggest that you practice this valuable technique as a form of doodling during odd moments, such as when talking on the phone or sitting in meetings.

EXERCISE 38

A Figure Drawing in Crosshatch

Materials:

Conte crayon, sanguine (reddish brown)

Eraser

Time needed:

30 to 40 minutes

Purpose of the exercise:

In the previous exercises in this workbook, you have used a smooth tone to delineate shadows. In this exercise, you will be copying a figure drawing by Alphonse Legros in which nearly all of the shadows are formed by hatched lines. As you can see, aside from the lines defining the edges of the form, the drawing is formed almost entirely with hatched lines that cross, not at right angles, but at very small angles. Crossing at small angles allows the artist to build up the hatches, creating even darker tones by slightly changing the angle with each overlapping set of hatches. You will draw your copy of Legros's drawing in conte crayon so that you can experience the nature of that medium.

Instructions:

1. Turn to page 139 in the workbook, with the printed format for use in copying the drawing *Seated Male,* by Alphonse Legros, on page 138. Note that the original drawing was in red chalk, a somewhat softer medium than conte crayon.

2. For this drawing, you will practice putting your skills on automatic by omitting the drawing of the crosshairs, using imaginary crosshairs instead.

3. Choose a Basic Unit—say, the bottom edge of the negative space above the thigh. Locate the Basic Unit by eye within the blank format and draw that edge. All proportions will be drawn relative to that edge.

4. Draw the outer edge of the figure, using negative spaces and sighting all angles and proportions.

5. Begin to hatch in the shadows, paying attention to the overall shape of each shadowed area. Notice that where the hatches cross, they cross at small angles, not at right angles. Right-angle crosshatches can be very awkward to work with, often producing a patchwork-like effect.

6. Turn both drawings upside down to compare the large shadow shapes and to see where the darkest areas fall. In those areas, build up layers of hatches by hatching back over your first sets of hatches, changing the angle slightly with each new set.

7. When you have finished, sign and date the drawing, adding the notation "After Legros."

Post-exercise remarks:

Crosshatching can seem like a complicated way to achieve a shadow shape, but the effect is so beautiful that the technique is well worth learning. It may have seemed difficult at first to "feather out" the hatches in order to make a smooth transition from a shadowed area to a lighted area. This depends partly on the amount of pressureyou apply with the pencil point. I recommend practicing crosshatching using varying pressures and varying amounts of spaces between the hatched lines.

Hatching is the mark of the trained artist. Learning to use this technique will give your drawings a professional look that is unmistakable.

**Alphonse Legros, red chalk on paper.
Courtesy of the Metropolitan Museum
of Art, New York.**

EXERCISE 39

An Imaginative Drawing Based on Leonardo da Vinci's Advice

Materials:

Small amount of ink, coffee, tea, or cola (preferably diet cola, because it contains no sugar that would make your drawing sticky)

Writing pen

Four or five sheets of newspaper

Time needed:

About 30 minutes of drying time and about 15 minutes for drawing

Purpose of the exercise:

Thus far, the exercises have been based mainly on something seen in the real world. This is a form of drawing called "realism." However, drawing need not be confined to portrayals of real life. Drawing can also depict the world of the imagination. One of the problems with imaginative drawing is finding a way to start. This exercise is inspired by the writing of Leonardo da Vinci, who recommended that artists study the stains on old walls to spark their imaginations with envisioned imaginative scenes and figures.

Instructions:

1. Turn to page 142 of your workbook, with the printed format. (For this drawing, you will not need the teaching and learning aids, the Picture Plane/Viewfinder, the Basic Unit, or the crosshairs.)

2. Place some sheets of newspaper beneath your drawing page. Carefully but deliberately spill some ink thinned with water, or some coffee, tea, or cola, within the format. Allow the liquid to run where it will, and then let it dry for about 30 minutes.

3. Study the stains on the paper, trying to "see" images triggered in your mind by the stains.

4. Using the writing pen, begin to reinforce the envisioned images with line, perhaps adding hatches and crosshatches to create three-dimensional forms.

5. Continue reinforcing images until you are satisfied that the drawing is finished.

6. Title your drawing. This is an important step and should be given some thought. Then, sign and date your drawing.

Post-exercise remarks:

This is a good exercise to repeat again and again in order to nurture your imagination. As you continue to draw images of the real world, your mind will become stocked with images of remembered drawings. For example, can you call up in your mind's eye the image of the flower you drew in Exercise 12, or the man reading the Bible in Exercise 19? These

images have remarkable longevity and are readily called up to guide your drawing when, for example, you want to draw a flower or a seated figure from your imagination.

Completely imaginary creatures and scenes evolve from amalgamations of remembered images. The process of drawing imaginary creatures itself helps you to envision images. For example, once you have drawn the head of an imaginary creature, the next part—the body—is generated as an imagined extension of the head. You then draw on the paper the image you see in your mind. The whole process of imaginary drawing is strengthened and enriched by having a large repertoire of remembered images from previous drawings, just as, for a creative writer, having a large repertoire of remembered writings helps with imaginative writing.

FANASY CREATURES OF COFFEE _SANDY C

EXERCISE 39 AN IMAGINATIVE DRAWING BASED ON LEONARDO DA VINCI´S ADVICE

EXERCISE 40

A Four-by-Four Drawing

Materials:

#2 and #4B pencils, sharpener, and eraser

A small piece of white paper, about 2" x 2", with a square ½" x ½" format cut out.

An object of your choice (for example, a dried leaf, a piece of jewelry, a piece of popcorn, a shell, bark from a tree, a flower, a rock, a piece of weathered wood)

Time needed:

About 1 hour

Purpose of the exercise:

The purpose of this final exercise is to demonstrate that subjects for drawings are innumerable and can be found everywhere, even in the most unexpected places. In this exercise, you will be drawing from an ordinary, everyday object, either human-made or from the natural world. You will enlarge a tiny area, ½" x ½", of this object to a 4" x 4" format to produce a drawing that may be unrecognizable as the original object but that will present a new, almost abstract image. This drawing will require all of the skills you have gained, from Pure Contour drawing through light/shadow to crosshatching and the perception of the gestalt.

Instructions:

1. Turn to page 145 in the workbook, with the printed 4" x 4" format.

2. Examine the object you have chosen. Use the paper with the small cutout square as a small version of the Picture Plane/Viewfinder to choose a composition that you like.

3. Carefully tape the paper format to the object and place it where you can closely view it.

4. Imagine crosshairs on the object and on the 4" x 4" format (or lightly draw in the crosshairs within the format if you wish).

5. Sharpen your pencil and begin to draw just what you see in the object, enlarging your observations from the ½" x ½" square opening to the 4" x 4" format.

6. Draw the main edges, spaces, relationships, and lights/shadows. Be sure to incorporate crosshatching in the shadowed areas of your drawing.

7. At the last stage of the drawing, work within the drawing itself to bring all parts to a point of finish, when you feel nothing needs to be added to the image. Make sure you emphasize spaces. Try to use a range of values, from very light to very dark.

8. Decide on a title. Titles and signatures become part of a drawing. Carefully write or print the title below the lower left-hand corner and sign the drawing below the right-hand corner.

Post-exercise remarks:

You have just completed an abstract drawing. You have abstracted, or drawn out, essential qualities from an object of the natural world. This is the definition of "abstract" art. These 4" x 4" drawings are very beautiful and stand on their own as real drawings. Even in drawing a small part of a very ordinary object, you may have experienced the perception of the gestalt during the time you were drawing or after the drawing was finished. I hope this inspires you to look for subjects to draw in unlikely as well as likely places.

Some Suggestions
for Further Study

To keep improving your drawing skills, the important thing is to continue to draw on a regular basis. Ten minutes a day is sufficient. Carrying a sketchbook is very helpful: I recommend a small sketchbook with blank pages that will fit in a purse, a briefcase, or a pocket. You may choose to use a pen, but if you prefer working with a pencil, you should also carry a small, hand-held pencil sharpener.

Time permitting, a drawing class will inspire you with new ideas, new subject matter, and a chance to see the drawings of other people. If this workbook is your first experience with drawing, I recommend a class in beginning drawing. Most beginning drawing classes focus on subject matter and a variety of mediums, not on the very basic strategies of perception that you learned in this workbook. Therefore, a beginning drawing class will probably not be a repeat of these lessons.

Some communities and schools hold uninstructed life-drawing classes, with no instructor but with a variety of professional models to draw from. This is the best possible practice, and the most rewarding, because the human figure is endlessly fascinating to draw.

You may become interested in adding color to your list of mediums. Colored pencils have the advantage of familiarity, since they are simply another form of pencil and so are not an entirely new medium for you. You may wish to try working with pastel pencils, a lovely medium and an intermediate step between drawing and painting. Pastel pencils are somewhat more accessible than pastel chalks for a beginner in drawing, and they are less dusty, as well.

My final recommendation is to go to see drawings in museums and galleries. You will learn a great deal from seeing how others have handled particular problems in drawing. In addition, find books in the library or bookstores that show reproductions of great drawings, and try to find time to copy some of those artworks. In times past, that is how artists learned to draw: by copying the works of great artists. We are fortunate in our own time to have reproductions so readily available.

No one ever finishes learning to draw, but that is one of the reasons why drawing can sustain your interest throughout a lifetime.

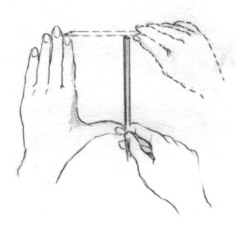

In time, you will discard your Picture Plane/Viewfinder. Using your hand and pencil to form a viewfinder, you will imagine the crosshairs, choose a Basic Unit, estimate its size *relative to the format,* mark it on your paper, and . . . just start drawing.

Portfolio and Video Ordering

The Drawing on the Right
Side of the Brain Portfolio
is a complete drawing course.
It includes:

A two-hour videocassette

Drawing board

Large drawing paper

Small drawing paper

Small template

Large template

Extra-large template

Red gel

Self-portrait mirror

Small Picture Plane/Viewfinder

Large Picture Plane/Viewfinder

Angle finder

Proportion finder

Erasable marker

Graphite stick 4B

Writing pencil 2

Drawing pencil 4B

Drawing pencil 6B

Pencil sharpener

Kneaded eraser

Plastic eraser

Tape

To order the complete Drawing on the Right Side of the Brain Portfolio or just the Video, complete this order form and mail or fax it to us at:

Drawing on the Right Side of the Brain
1158 26th Street, Box 530
Santa Monica, CA 90403

Fax: 562 595-7572
Internet: Or order via the Internet at www.drawright.com
Telephone: 888 DRAW-101 (888 372-9101)

Sales tax will apply for California.
Please allow two to four weeks for delivery.
Shipping charges will be added—visit our website or call for a quote.
Delivery method: UPS

FIRST NAME LAST NAME

ADDRESS

CITY / STATE / ZIP

PHONE E-MAIL ADDRESS

Payment method:
○ Check or money order payable to *Drawing on the Right Side of the Brain, Inc.*
○ Mastercard ○ Visa ○ American Express ○ Discover

CREDIT CARD NUMBER EXPIRATION DATE

AUTHORIZED SIGNATURE

Items ordered:	*Quantity*	*Item*	*Price*	*Total*
		The Portfolio *(includes the video)*	$99.99	
		The Video	$29.99	
			SUB-TOTAL	
			SALES TAX (CA)	
			SHIPPING (UPS)	
			HANDLING	$3.00
			TOTAL	